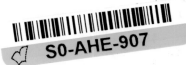

HOW TO SHOOT AND SELL SPORTS PHOTOGRAPHY

DAVID ARNDT

AMHERST MEDIA, INC. ■ BUFFALO, NY

Published by:
Amherst Media, Inc.
P.O. Box 586
Buffalo, N.Y. 14226
Fax: 716-874-4508

Publisher: Craig Alesse
Project Manager/Senior Editor: Richard Lynch
Associate Editor: Michelle Perkins
Copy Editor: Paul Grant
Image Technician: John Gryta

ISBN: 0-936262-72-9
Library of Congress Card Catalog Number: 98-72742

Printed in the United States of America.
10 9 8 7 6 5 4 3 2 1

TABLE OF CONTENTS

INTRODUCTION

IMPROVING YOUR PICTURES AND MAKING MORE MONEY

How to Shoot and Sell Sports Photography is a step-by-step guide for those seeking to develop the skills and knowledge necessary for success in this exciting and demanding photographic specialty. After reading the book, studying the pictures and practicing the techniques, photographers will know how to:

- select cameras and lenses to use in particular situations
- select the best film for each project
- prepare for each assignment
- shoot more successful pictures per roll of film
- create thrilling sports action and feature photographs
- use pictures to tell a story
- differentiate between good and bad photos
- find potential clients
- customize a portfolio for every potential client
- correctly price photographic services

- sell more pictures, for higher prices, to more markets
- use basic sales techniques to win more assignments
- increase profits through accurate financial records
- work with an agent
- resell previously published pictures

"...use basic sales techniques to win more assignments..."

HOW TO USE THE BOOK

This book is organized into easily understood bites of valuable information. Methods, techniques and tools are described. Each element is discussed in detail. Many elements are illustrated with pictures. Some pictures illustrate errors and poor technique, others are portfolio quality pictures. Portfolio pictures help set performance standards and goals to achieve.

The organization of *How to Shoot and Sell Sports Photography* allows readers to access data without reading massive amounts of text. The table of contents and index facilitate random access to specific information.

PREREQUISITE KNOWLEDGE

It is assumed that the reader has some knowledge of sports and photographic skills. Knowledge of basic black and white processing is needed to understand the sections on special film processing techniques. Segments covering *f*-stops, shutter speed and film speed require the reader to know what these terms mean and how they relate to each other. Knowledge of how each sport is played is very helpful. These fundamental topics are well covered in a myriad of books, so it is not necessary to repeat them in these pages.

PICTURE SELECTION

The only professional athletes appearing in this book are rodeo cowboys, professional wrestlers and bicycle racers. Because most beginning sports photographers do not have access to the sidelines of professional sports teams, pictures made at professional games are excluded from this book.

CHAPTER 1

THE BASICS

THE ESSENCE OF SPORTS PHOTOGRAPHY

Sports, reduced to its essence, is about people in competition with other people. Even in a technologically dependent sport, such as auto racing, the competition is primarily between drivers. Fans identify with a driver or driving team. Links might be forged for many reasons: for example, the team and the fan may be from the same city, or the fan may have met a player or attended the same university. Regardless of the cause, a link exists.

Because of this personal identification, fans want to get closer to players. They want to know what their favorites are doing. They want to know what it is like to play the game and what their player is feeling. ABC Television's Wide World of Sports slogan ("The thrill of victory and the agony of defeat") defines what sports journalism tries to convey to the fan. The most successful sports pictures illustrate these powerful emotions.

Almost as interesting as a picture that shows emotion is an action picture which captures a moment in time and tells the story of the game. One of the ways to achieve this is with a picture shot at the decisive moment in the progress of the play. Peak action is extremely difficult to catch consistently, therefore much of this book is devoted to the tools and techniques that capture action pictures.

ELEVEN CRITICAL ELEMENTS OF SPORTS PHOTOS

Successful sports photos can be analyzed and the elements that contribute to their visual and narrative impact can be identified. Some of the elements, such as exposure, shutter speed, and focus, are technical in nature; others are artistic and journalistic. The elements in alphabetical order are:

1. Ball
2. Caption
3. Color
4. Composition
5. Conflict
6. Context
7. Emotion
8. Exposure
9. Focus
10. Peak action
11. Shutter speed

Each picture contains different combinations of the eleven elements. The following pictures illustrate each element.

BALL: A basketball in just the right place makes this a funny picture. The title, "A Head for Basketball," provides a punch line. Move the ball and there is no point to the picture. Action pictures of many sports generally need a ball, puck or a birdie in the picture.

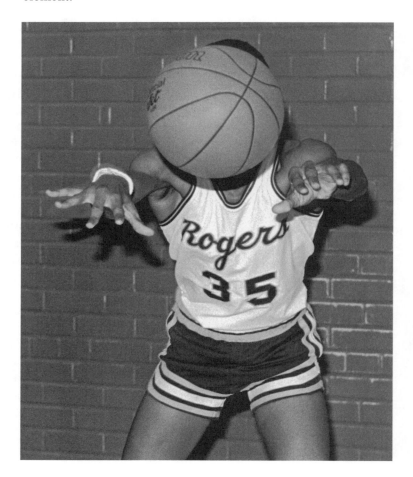

CAPTIONS

Captions are also called cutlines. Cutlines vary in length from just the subject's name to as much as 200 words. Several captions could be written for this play. The picture can be described from the blocker's perspective, the runner's perspective, the home team's perspective or the defender's perspective. Even an imperfect photo can be enhanced by a well written caption. This picture is isolated and without context. Without a caption the reader could not know who won the game, or the impact this play had on the outcome.

To write a cutline, describe exactly what is happening in the first sentence. Be sure to include the uniform numbers so the reader can identify the players in the picture. For example:

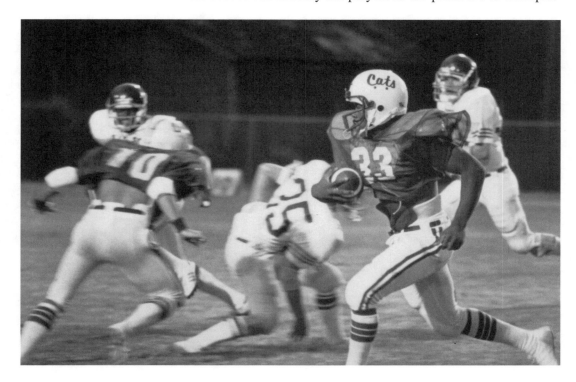

■ Bill Smith (33) scampers into the end zone for the first touchdown.

Additional sentences provide more details. For example:

■ On this play, Smith scored the winning point with one second left in the game.
■ In the third quarter a crushing tackle tore quarterback Bill Smith's hamstring. He will miss the next two months of play, according to coach Jimmy Jones.

Write the caption in present tense and active voice.
Active voice is more interesting and conveys action vividly.

Correct: Tom Clark (14) catches a 30 yard pass
from quarterback Bill Smith (33).
Incorrect: This pass from quarterback Bill Smith
(33) was caught by Tom Clark.

COMPOSITION: *This picture works even without the puck, the player's face, or any action. It works because the composition plays up the goalie's body language. He is wound up, ready to spring and block the puck. The composition enhances the tension by showing empty space ahead of the player and little space behind him. The empty space poses a question to the viewer: "What is happening that you can't see?" By begging the question, the composition creates tension and drama.*

Before each game, obtain rosters of the teams involved so you can identify the players when writing captions. A misidentified player or misspelled name is embarrassing for you, the publication and the player.

Make notes during the game so you can identify your shots. This means being able to identify the rolls in order, as well as the frames. One clever technique is to photograph the scoreboard at the start of each roll. This identifies the score, quarter and time for each roll. Also photograph the scoreboard after each score is recorded. This gives helpful clues for locating important plays on your film.

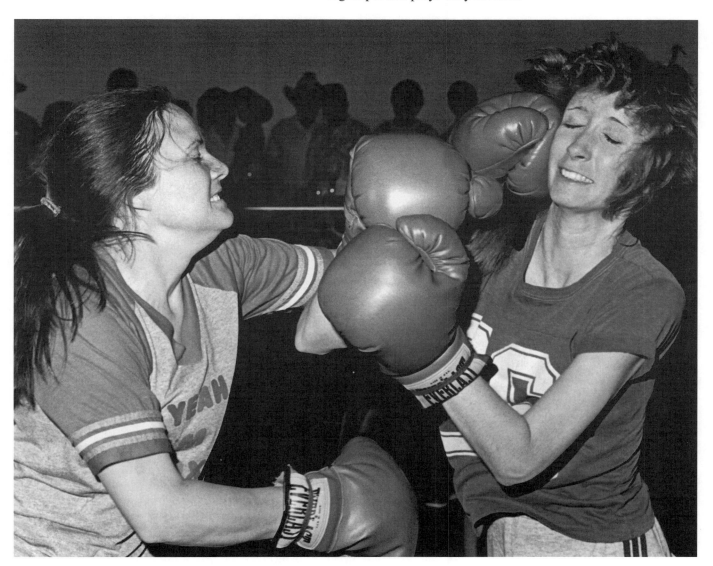

CONFLICT: As one boxer lands a punch, the victim reels in pain from the impact. This picture is all conflict, emotion and peak action. The fact that women are boxing merely adds novelty and news value to the image.

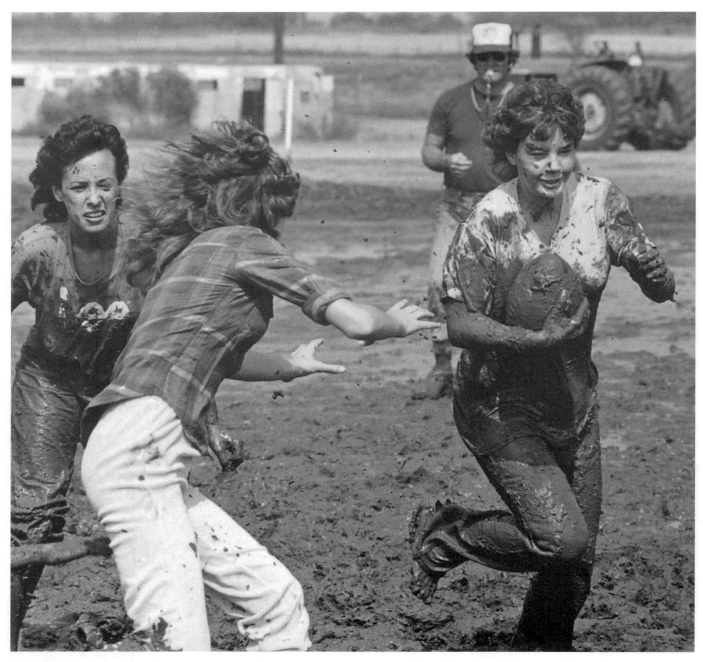

CONTEXT: *The playing environment might be more interesting than the game. Here, a photographer documented a women's football game played in a farm field which was deliberately plowed and turned to mud. The tractor in the background helps tell the story. Context is influenced by controlling the area in focus. This is done by lens selection, shutter speed and aperture control.*

Long lenses and low f-stops create pictures which isolate players from the environment and the rest of the players. Isolating players is a very popular style in sports photography because the same picture of a famous player can be sold several times a season. In that case, isolating the player from the context of the game can make the shot more valuable.

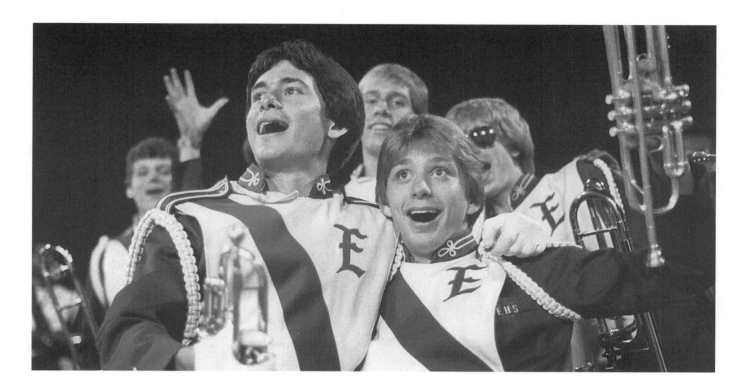

EMOTION: (above) Winning or losing brings emotions to faces. Joy on the faces of these musicians make this a successful picture. In fact, this picture was published on the top of page one, while the game action pictures were buried deep inside the paper on the sports page. Pictures that can be run on the front page or a magazine cover are more valuable to editors and photographers than action pictures. This is a fine way for a photographer to boost income.

EXPOSURE: (right) This picture of a women's bicycle race in Fort Worth, Texas, is slightly underexposed but is usable because expressions, composition, context and caption contribute to tell the story of the race. Sports photography does not have to be perfect to be publishable. The picture was shot as an experiment with Konica ISO 1600 color print film. This film was extremely contrasty and had a strong blue cast. Tests showed that the film should have been rated at ISO 1200. Test new products before using them on an important assignment.

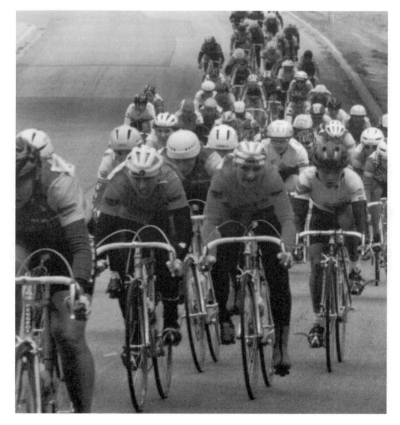

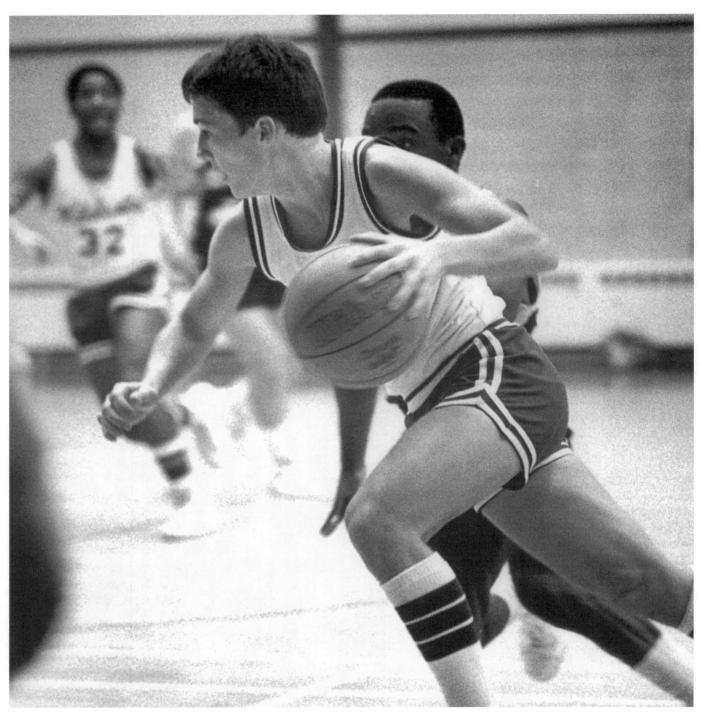

FOCUS: Getting action shots in sharp focus is very difficult. An ideal photo will have the face of the central player in focus. Many good pictures fail this test. Even Sports Illustrated will publish a picture that is not razor sharp if it has other redeeming qualities. This is especially true if the shot is the only one available of a key play. Image editing computer programs are capable of making slightly out of focus pictures crisper. Another fix is to publish the picture in a small size. Occasionally it is important that some areas of the image be out of focus to prevent distractions. An alternate meaning of the term focus is the photographer's choice of subject. A photographer may shoot only pictures of one player or type of play. This is also called editorial focus or perspective.

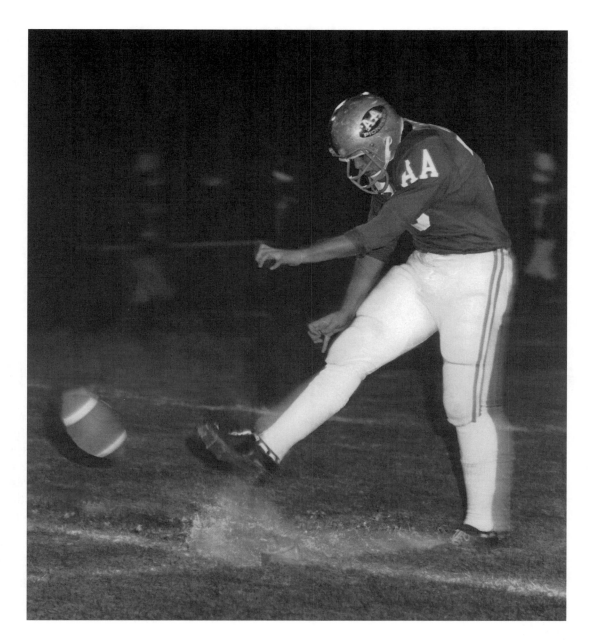

PEAK ACTION:
The ball is inches
from the kicker's
toe. Timing on this
shot is just about
perfect. The same
scene a fraction of
a second before or
after would be a
failed image.

SHUTTER SPEED

Most sports photos are shot using fast shutter speeds, typically 1/250 second or shorter. Fast shutter speeds are good at stopping motion. For example, shooting a picture of a passing motorcycle with a fast shutter speed can freeze the action of the bike and rider. At a slow shutter speed (slower than 1/250 second) would probably cause blurring of the action in the image. Shutter speed can be used for creating effects. Panning with the motion of the motorcycle at a slow shutter speed could create the illusion of speed, by freezing the motorcycle and rider while blurring the background.

"Good pictures
come from knowledge
and preparation..."

PREPARING TO SHOOT

"Lucky" pictures are rare. Accidentally being in the right place at the right time with the right film, the right equipment and perfect timing does not happen very often. Good pictures come from knowledge and preparation, not accidents. A well-prepared photographer returns from every game with usable pictures and frequently captures exceptional action pictures. The following steps should be taken before going out to shoot.

STUDY THE TEAMS

Knowledge is power! Coaches and players study films of their opponents so they are familiar with the opposition. They are prepared. They know what to expect in every situation. Their pre-game preparation allows them to create a defense and offense geared to the capabilities and limits of the enemy. Photographers should do the same. Knowing which play to expect gives photographers time to move into position for the most exciting perspective. Each team has star players and favorite plays for certain situations. Learn to recognize these plays and players.

Coaches and players routinely answer strategy and tactics questions from reporters. They are also willing to help photographers, so a day or two before the game, talk to the coaches and players. Ask for tips on what plays to expect in typical situations. They will usually be very happy to help. They know good pictures make them look good. Thank them by giving them copies of your best pictures.

POSITION

Sportscasts of football games constantly hammer home the point that a team's success depends on field position. The closer a team is to the goal the more likely they are to score. A sports photographer's chance to score an outstanding photograph also depends on field position. If the photographer is not at the right place, at the right time, with the right tools he fails to get the picture.

For most plays the ideal location is ahead of the anticipated action. Take a position so the team on offense is moving toward the camera. This allows faces of the players to be seen.

Detailed positioning advice and sample pictures can be reviewed elsewhere in this book.

CHECK EQUIPMENT

Paranoia is a positive mental condition in the high pressure field of professional sports photography. There are several items photographers should be paranoid about, if they are wise.

Cameras and other tools must function properly for sports photographers to succeed. A beneficial habit to form is to test operation of the cameras, lenses and flash equipment before every shoot. The consequences of failure to complete an assignment could be loss of a client and money.

Shutter function can be checked by triggering the camera with the back open. See if the shutter opens and closes at 1/250, 1/60 and 1/15 of a second. If the camera works, light will be visible through the lens and shutter.

Test lenses with the camera back open to see if the lens iris closes during exposure. Try several aperture settings.

Test lighting equipment by shooting a picture to trigger the flash. With the camera back open hold the flash in front of the lens. The bright light from the flash must be visible through the shutter. Be sure the shutter is set to the flash synchronizing speed. If the camera is not synchronizing with the flash, or the shutter is set too high, only part of the shutter will be open during the flash.

Dead batteries cause dead cameras. Always carry a spare set of fresh batteries for the camera, motor drive and flash. Most cameras have a method of testing the battery. The process is described in the user's manual.

Triple check to confirm that film is loaded in the camera. Imagine the embarrassment of a photographer telling a client that she forgot to put film in the camera.

Always carry a spare camera and flash. Equipment may fail or be damaged during use.

Camera settings may change accidentally while in use. Double check the shutter speed, lens aperture, auto exposure

mode and film speed (ISO) frequently during each game. Active photographers learn to use and adjust their cameras without looking. They can tell the shutter speed by the sound it makes and which f-stop is selected by touch. A malfunctioning camera sounds and feels different than normal.

FILM CONSUMPTION

Carry more film than needed to get the desired picture. Photographers should consume moderate amounts of film at important games. Twelve to twenty-four rolls is typical. This is not wasting film! Shooting several rolls of film improves the likelihood of catching a spectacular moment or the key play of the game. Some experienced photojournalists plan on finding only one useable picture for every roll shot. The national sports magazines are so picky they may find only one acceptable shot in 10 rolls. Small publications may insist on a tighter film budget knowing they will have fewer good pictures to choose from.

"Carry more film than needed to get the desired picture."

CHAPTER 3

GUIDELINES FOR PHOTOGRAPHERS

OBTAINING PERMISSION TO SHOOT PICTURES

In public places (areas ordinary people can enter without paying a fee) do not ask the subject for permission to shoot a picture. Permission is not needed to take the picture or to publish photos for journalistic purposes when the event or activity is freely available to the public. Obtain the subject's name after the picture is made so you have all the information you need to write the caption. The possibility of their picture being published thrills most people. Being published gives them a moment of fame. [*A discussion of libel, invasion of privacy and copyright issues specific to photography is in Chapter 6.*]

CREDENTIALS

Restricted access to the sidelines at professional, college and school games is normal. Gate keepers and police check credentials before allowing entry to sidelines.

For example, the Dallas Cowboys issue photography credentials with three levels of access. The first priority allows the closest approach to the sideline. The lowest priority allows photographers to stand behind the first two rows of photographers and shoot over their heads or between the bodies.

Sideline passes might look like this one issued by Southern Methodist University (SMU). At SMU the credentials include free food before the game. SMU also issues special parking permits for spaces close to the press entrance.

For public school and college photo passes, call the athletic department or the public relations office to request credentials. Two weeks advance notice gives the staff time to mail the pass. In city or privately sponsored leagues, contact the Recreation Department or league officials. Requiring credentials is a part of providing security for athletes. Always cooperate fully with police or security personnel.

PROFESSIONAL BEHAVIOR

Ground rules at professional games require that photographers to stay five yards outside the field. The boundaries are marked. Referees will move snapshooters back from the edge of the field during the game as necessary. Always learn and follow the local rules; teams and leagues have the power to keep photographers off the field for any reason they wish.

The National Football League and some schools forbid photographers from mingling with players in the bench area. This forbidden zone lies between the 25 or 30 yard lines. Enforcement of this rule varies from team to team. High schools and small colleges give photographers more leeway because schools crave publicity generated by news media.

SAFETY

SMU places a warning on the back of the photo pass. Sports photography is dangerous. Players are injured in every game and photographers are also at risk. The author was knocked down in 1974 by a 300 pound Ohio State University lineman. The impact shattered a 135mm lens.

■ SAFETY RULES INCLUDE:

- Stay alert. Watch every play, even while changing film or chatting with a friend.
- Dodge sideline activities. Players, coaches and officials have first use of sidelines. Sidelines are their territory. Photographers are guests. There is no "right" to shoot pictures from sidelines.
- Watch out for other photographers and television crews. At televised football games a video camera, mounted on a truck, moves up and down the sidelines following the action. In 1997 a photographer was reportedly run over at a football game by an ABC television camera truck.
- At important games, hundreds of photographers have press credentials. Photographers crowd three rows deep at Michigan - Ohio State football games. Tempers flare in this

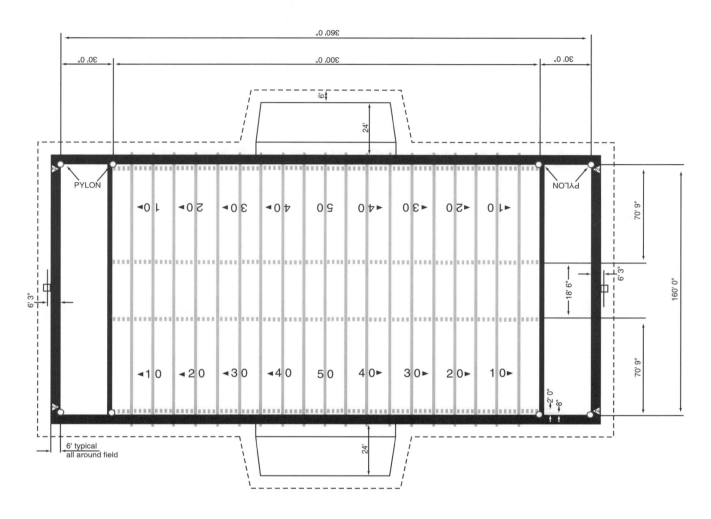

The diagrams above and on page 22 detail the exclusion zones, which delineate the areas where photographers should not intrude. Dashes mark the boundaries. To assure a continued welcome at games, stay outside the restricted zone.

high pressure, competitive environment. Be polite. Watch where you step.

■ Stay nimble. Keep your equipment pack lightweight and be ready to run from a charging player.

■ A few sports, such as rodeo or motor racing, are extremely dangerous for photographers. Always stay behind the safety barriers and have an escape route planned.

Do not expect players to look out for your safety. Given a choice of not smashing into you or scoring, players will take the points every time. Helmets and padding protect the players, but nothing protects the photographer.

Tripods are dangerous because they are difficult to move quickly, and take up too much space on crowded sidelines. Pros prefer to use monopods to support super-telephoto lenses. They are lighter, easier to move, and they take less time to adjust after the photographer changes locations.

NFL BENCH AREA SHOWING RESTRICTED ZONES

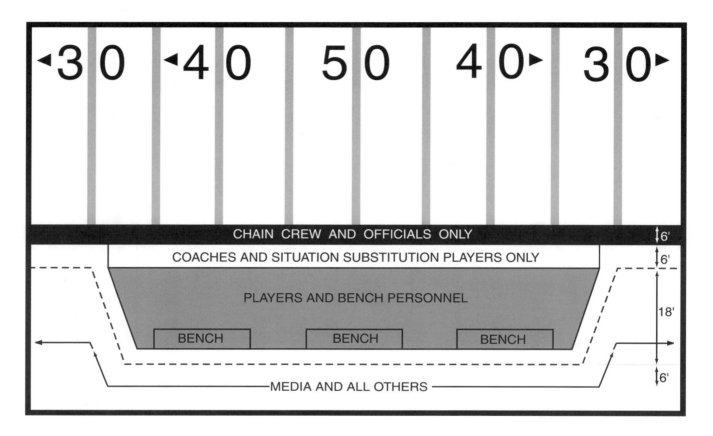

The diagram above shows details of the restricted zone around the bench area. Dashes mark the boundaries. Again, stay in the permitted zone.

REMOTE CONTROLS

Remote control units are available to trigger cameras from as much as a mile away and should be used in very dangerous situations or when a photographer cannot physically be present. Remote controls allow cameras to be mounted on aircraft wing tips, inside demolition derby cars or underwater during swimming and diving events.

FLASH

Rules limiting flash photography vary. Some players and coaches insist on available light pictures only. They contend the flash blinds their players momentarily and thereby prevents the player from performing for several seconds.

High powered professional flash units disrupt television broadcasts by overexposing video cameras for an instant. Broadcasters may request that flash units be turned off during game action. Comply with their requests if the pictures can be made with available light. Broadcasters pay for television and radio rights. Sports photographers get in free.

CHAPTER 4

EQUIPMENT & TECHNIQUES

Historically, sports action photographers used cameras ranging from point and shoot types to 4x5 inch glass plate cameras. In the hands of a talented photographer any camera can record exciting pictures. The choice of serious amateurs and professionals is the single lens reflex (SLR) camera. SLRs offer a versatility unmatched by any other camera style.

Professionals may carry two or three cameras, each with a different lens. Multiple cameras permit shooting different game situations without changing lenses. Cameras and lenses are status symbols among pros. New equipment indicates high income and success. Battered equipment gives their owners the status of years of experience. Leicas provide the highest status level.

35MM CAMERAS

The Leica R8 is the newest SLR from E. Leitz. Leicas have long been known as highly durable cameras with the best lenses made. The quality justifies the high prices these cameras command on both the new and used markets.

Canon makes a wide range of SLR cameras and lenses. The company is very popular with sports photographers because of the quality of their products and extra support services Canon provides for professional photographers.

Pentax often leads the camera industry with technological innovations. In addition to 35mm SLR cameras they make several popular lines of medium format cameras.

Leica R8

A Pentax ZX-M

Nikon makes cameras and lenses which are popular among photojournalists and professional photographers. Their reputation began with news photographers covering the Vietnam war in the early 1960s. The Nikon combination of quality, price and accessories is hard to beat. They also provide special support programs for professional snapshooters.

Other companies which make 35mm cameras for professional photographers include Minolta, Olympus, and Contax.

MOTOR DRIVES

Motor drives are essential tools for sports photographers. They allow shooters to take pictures and follow the action without having to advance the film. They are also used to capture rapid sequences of pictures. Drives are rated in frames per second. Commonly available models have frame rates from one to 10 frames per second. Be aware that motor drives are noisy. Golfers hate the distraction caused by motor drive whine.

FLASH

If the light is too dim for available light pictures, shoot the game with on-camera flash and wait for plays to come within 20 yards of the sidelines. Flash photography limits picture opportunities the following ways:

- The background will be underexposed.
- Flash recycle time is slow and it is probable that only one shot can be made per play.
- Flash may distract or temporarily blind players.
- Flash disrupts television coverage.
- Slow flash sychronization may cause blurring, streaking or ghosting, which is the result of the shutter remaining open longer than the burst of flash.

Most 35mm format cameras synchronize the flash with the shutter at 1/60 of a second. The flash lasts only 1/1000 of a second but the shutter is fully open for much longer than the flash. As long as the shutter is open the film continues to receive light. If the subject is moving, a blur appears in the picture. If the amount of light on the subject is near the proper exposure for the film then a ghost image happens. A few cameras synchronize at 1/90, 1/125 or 1/250 of a second. The higher the flash synchronization speed the less visible the blur. Blur disappears with shutter speeds above 1/250. Ghost images can be used creatively to convey a sense of motion or other-worldliness.

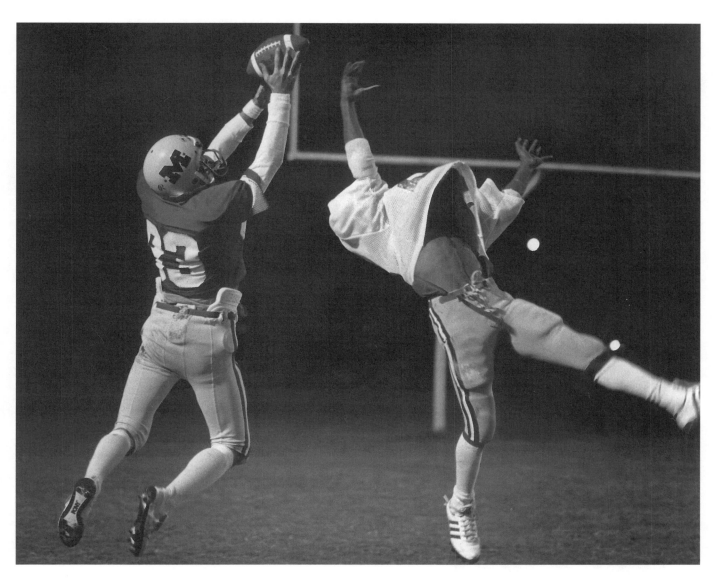

This dramatic pass reception was caught by a 135mm f2.8 lens and an on-camera flash. A 200mm lens is nearly the longest that can be used with a flash. Longer lenses are useful for more distant plays but the action may be beyond the capacity of the flash.

LENSES

A full range of lenses can be employed to shoot sports pictures. The lenses below are covered in the following pages.

- Fisheye and 20mm lenses
- 28mm and 35mm lenses
- 50mm lenses
- 85mm and 100mm lenses
- 135mm and 180mm lenses
- Zoom lenses
- 200mm lenses
- 300mm lenses
- 400mm lenses
- 500mm lenses
- 600mm lenses

(above) A Canon 15mm fisheye lens.

(right) A Canon 20mm extreme wide angle lens.

A Canon 28mm wide angle lens.

■ FISHEYE AND 20MM LENSES

Fisheye and extreme wide-angle lenses provide unusual perspectives and distortions. These are useful for tight spaces such as sideline shots or at close quarters in a crowd. Some fisheye lenses produce circular images, others fill the full 35mm film area. They often approach a 180 degree field of view. These lenses were originally developed for astronomers wishing to photograph the entire night sky at once. 20mm lenses have a field of view of 94 degrees. Both lenses visibly distort perspective when compared to normal human vision. Some photographers use the unusual perspectives and distortions to give their pictures an unusual look.

■ 28MM AND 35MM LENSES

28mm and 35mm lenses function well in close quarters with less distortion of the images and perspective than fisheyes. These wide angle lenses have angles of view of 75 and 64 degrees, respectively. If it is not possible or desirable to step back five feet from the action, consider using these lenses to help fit more into shots where you will be close to the subject.

(above) Pictured is a super fast f1.0 lens made by Canon.

(below) A Canon 135mm f2.8 short telephoto lens.

50MM LENSES

The 50mm is called the normal lens because it is sold with most 35mm SLR cameras. The lense is very versatile, offering *f*-stops in the 0.95 to 2.8 range, though *f*1.4 and *f*1.8 are the most common varieties. Such large *f*-stops make this lens the preferred optic for available light photography. Use it in dim light situations and when flash photography is inappropriate. The 50mm has a 46 degree angle of view.

85MM AND 100MM LENSES

These are wonderful for events up to 15 yards away, portraits, and for flash photography. The 85mm is the author's favorite lens for mid-court basketball action. The 85mm has an angle of view of 29 degrees while the 100mm is slightly tighter at 24 degrees. Some manufacturers make two versions of the 85mm lens; one has deliberately fuzzy focus which is desirable for some styles of portraiture, the other model is razor sharp. Check carefully before buying to be sure of getting the sharp version. The 100mm lens is also available in a macro-focusing configuration.

135MM AND 180MM LENSES

Use telephoto lenses such as a 135mm and 180mm for available light pictures if they boast apertures between *f*2 and *f*2.8. These lenses also work well for nearby plays and flash shots. The 135mm lens is very popular as a second lens with amateur photographers. Sporting an 18 degree angle of view, shooters can capture frame-filling action without danger.

■ 85 - 200MM ZOOM LENSES

This is the ultimate multipurpose lens. It serves well for most daylight action and sideline picture opportunities. This zoom comes in two configurations. One style has separate focus and zoom rings. The other style has just one ring that combines the zoom and focus function. Test both and buy the one that works fastest.

Canon 85mm to 200 zoom lens.

■ 200MM LENSES

200mm $f2$ or $f2.8$ lenses transmit more light than zoom lenses and are useful in dimly lit stadiums. The angle of view is only 12 degrees. Most of the pictures in this book were made with a 200mm lens.

■ 300MM LENSES

The $f2.8$ lens enlarges images of mid-field plays to useable sizes and still permits available light photography at many night games. This is the premier sports photography

lens and gets a photographer respect among other sports photographers. Because they are so expensive, only serious sports photographers buy them. Bringing one of these monsters to a game tells everyone the owner is serious about sports photography. The 300mm lens has an 8 degree field of view. A monopod is an essential tool for holding the 300mm lens steady, regardless of shutter speed used.

■ 400MM LENSES

A 400mm ƒ2.8 lens is suitable for bringing in more distant plays and completely isolating the play from the background. The angle of view is 6.2 degrees.

■ 500MM LENSES

500mm ƒ8 mirror lenses are light and compact, but are so dim they are hard to focus and nearly impossible to hand hold. Also, out of focus highlights form doughnut shaped circles. The angle of view is 5 degrees.

500mm lenses which use conventional lens designs are great for distant plays.

Canon 400mm ƒ2.8 lens.

This Canon 35 to 350mm lens functions well when only one lens and camera is practical.

600MM LENSES

600mm *f*4 lenses are designed to shoot plays on the other side of a football field or from other sports where the safety of photographers is a concern. Mount this behemoth on a tripod for steady pictures.

MISCELLANEOUS LENS NOTES

Canon's 35-350mm lens is versatile but very large and awkward to hold and use. 300mm and longer lenses cannot be hand-held at shutter speeds below 1/250 of a second. A monopod attached to the screw mount on the 300mm lens reduces camera motion when longer exposure times are needed. The *f*2.8 version features a front glass that captures four times as much light as an *f*4 lens.

Photographers without 300, 400, 500 and 600mm lenses compensate in the darkroom by increasing the enlargement of the print and cropping tightly. Picture editing software such as Adobe Photoshop can also crop and enlarge the picture.

AUTO FOCUS

Auto focus lenses are very popular among amateur photographers and they work well for sports photography under some circumstances. Early auto focus lenses were built for novice photographers that did not know how to tell if an image was in focus. The lenses had weak, slow motors that could not keep a person in focus if he or she were walking toward the camera. Technology has improved some in the past twenty years but a wise sports photographer would test the auto focus lens before buying one.

BACK-UP TOOLS

Cautious professional photographers always carry a spare camera in case the primary unit breaks. Cameras can be expected to last two to five years in the hands of active photojournalists. The same caution is necessary with flash units, and their wimpy synch cords. Synch cords and flash units are generally quite fragile and they must be replaced regularly. A synch cord has a life expectancy of only a few weeks of busy professional use. A flash may last two years.

DIGITAL CAMERAS

Digital cameras were invented to take advantage of the desktop publishing revolution started with Macintosh computers. Early digital cameras had image resolutions as low as 320 x 160 pixels. Some were greyscale only, others had trouble recording accurate color.

The newspaper industry led the change to digital photography for five reasons:

1. Digital cameras skip the processing steps that slow down traditional film photography. Pictures can be shot closer to publication deadlines. This improved the ability of newspapers to compete with broadcasters.
2. Publishers discovered the savings on film and processing supplies paid for expensive new digital cameras in less than one or two years.
3. The low resolution provided by early digital cameras was better than the reproduction quality of most newspapers, so the reader did not observe a quality change.
4. Photographers no longer had to spend several hours a day processing film. More assignments could be completed with fewer photographers, thereby cutting the salary and benefit expenses.
5. Archiving pictures became easier and less expensive.

As image quality improved manufacturers started adding SLR-type features. Current digital cameras are available with built-in 10x zooms, or use interchangeable SLR lenses. They also feature flash synchronization, adjustable shutter speeds and apertures, auto exposure and interchangeable disks.

The Leaf camera back for 4x5 inch film delivers better resolution than a traditional 4x5 view camera using ISO 100 film, but each exposure takes several seconds to complete. The exposure time rules out the opportunity to photograph moving objects.

Kodak makes some fine digital cameras using Nikon and Canon camera bodies. However, when they were first introduced these cameras were priced in the $25,000 range. On February 5, 1998, Canon and Kodak introduced a new digital SLR camera body with the following features for a list price of $14,995:

■ 1728 x 1168 lines of resolution
■ 1.8 inch color LCD monitor
■ an ISO that is adjustable in the 200 to 1600 range
■ 3.5 frames per second 12 frame bursts
■ uses Canon lenses and accessories
■ calibrated through-the-lens flash metering
■ automatic white balance
■ an IEEE 1394 FireWire cable for quick downloading of images to computers

- slots for Type II and Type III PC cards which can hold up to 199 pictures
- software for Macintosh and Windows 95 computers

On the same day, February 5, 1998, Polaroid announced new digital products, including a digital camera back that fits many brands of 35mm SLR cameras, and a combination digital and instant print camera, the PDC-3000.

By 1998, many manufacturers had introduced digital cameras. Priced in the $1000 to $3000 range, they offered some of the features of a 35mm SLR and a resolution of about 1000x800 pixels.

The process of preparing pictures for printing involves converting them to a series of dots. The process is called screening. Newspapers screen their photos at less than 100 dots per inch (dpi). Some use screens as coarse as 75dpi. A picture shot at 1000x1000 pixels per inch is the same as being screened at 1000x1000 dots per inch. In theory, the shot could be enlarged to 10x10 inches without losing any resolution if the publication uses a 100dpi screen. If the publication uses a 50dpi screen the image size could be inflated to 20x20. But, as most pictures are cropped, the useful portion of the image will probably be much smaller.

Generally, newspaper pictures are published no larger than 4x6 inches. Printed picture quality is mostly determined by the newsprint it is published on. Newsprint is made in several grades which varies from photographically poor to very bad. The poorer the paper the lower the dpi that must be used to avoid blurry pictures.

Quality and resolution of digital cameras is improving quickly. Many magazines are now using digital images, as are some advertisers. Some day, film-based cameras may be as obsolete as manual typewriters.

FILM SELECTION

The lower the ISO, the better the resolution of the film. Color slides and color print film are available in speeds from ISO 64 up to 3200. High sensitivity films (above ISO 400) are very grainy and sometimes display odd color balances. Some stadium lights cast odd unnatural colors. Most publications can work from either slides or prints. Color slides are generally the least expensive to process.

There is no perfect film. Dozens of film stocks are manufactured and marketed to photojournalists and amateur photographers. Film choice affects the quality of the final image in the client's publication and photographer's profits. Even a few pennies saved per roll (whether in initial purchase price

"Many magazines are now using digital images..."

or developing) can add up to hundreds of dollars per year when multiplied by the thousands of rolls of film consumed by a sports photographer.

Clients that use color pictures normally expect to work with color slide film. With slide film, photographers do not have to pay for enlarged prints. Color balance issues are simplified because the results are not affected by the color printing skills of the laboratory technician.

Depending on the availability of scanning equipment, it may be desirable to make prints of your images. With print film, the results of the shoot are known in just 45 minutes rather than waiting for film to return from a laboratory (assuming you do not wish to invest in RA-4 slide processing chemistry and deal with the fine temperature tolerances it requires). Some labs cater to professional photographers by processing slides in about an hour. This service commands a premium price.

Kodak is marketing a line of color print film designed specifically for photojournalism. The products are part of the Ektapress family and include film with ISO of 200, 400, 800 and 1600. Ektapress PJC1600 can be pushed by Kodak and some professional labs to ISO 3200 and 6400. The Kodak Gold line of print film includes ISO ratings of 100, 200, 400, 800 and 1000. Kodak has two lines of slide films, Kodachrome and Elite II, which replace the venerable Ektachrome family.

Fuji Photo Film Company is aggressively marketing its line of slide and print film to professional photographers in the United States. They are highly successful in the portraiture and wedding photography markets. Fuji sells a slide film that is rated at ISO 1600. This is very popular film.

Ilford, a major film maker from the United Kingdom, limits its United States efforts to black and white films. Some photojournalists feel the Ilford films are superior to the Kodak products. About 20 years ago Ilford introduced an ISO 400 film that can be processed in C41 chemistry. C41 is for color print film processing. Ilford also has a fine selection of standard black and white film. The 400 speed film can be pushed to ISO 3200 according to published charts.

Agfa, a German film company, also makes a highly respected family of black and white, color print and color slide films.

An effective method of choosing a film is to meter the available light at the event and pick the film with just enough ISO rating to allow the camera to freeze the action with a shutter speed of 1/250 or 1/500 and an appropriate f-stop. This gives priority to the shutter speed settings, yet it guarantees the sharpest, least grainy picture possible.

LIGHT

Lighting is a major issue for photographers. The color balance of artificial lights may be very different than daylight. There is never enough light indoors or at night games. An invariable rule is: the smaller the seating capacity of the venue, the dimmer the light. Architects design stadium lighting to fit construction budgets. Architects will boost light level and plan for better color balance if they anticipate frequent television coverage of events or a need for the improved safety bright lights provide. Lighting receives a low priority in stadium construction because human eyes can perceive the world in color over a very wide range of brightness. Film is not, however, as flexible as human eyes, so poor lighting can become a big issue.

◼ AVAILABLE LIGHT PHOTOGRAPHY

Shooting without flash is called available light photography. Available light pictures at night or indoors require film with ISO ratings of 1200 or higher. The minimum shutter speed needed to freeze action is 1/250. Available light exposures range from $f2$ to $f4$ at 1/250 or higher. Typically, medium and large arenas have enough light to shoot action pictures with available light.

Few lighting systems use bulbs that illuminate over the entire spectrum of visible light. Unnatural color tint and hue is the result. Try tungsten balanced film to see if it improves color balance. Image editing software may be able to correct picture tint.

The color balance of some lights changes 60 times per second. For instance, mercury vapor lights flicker during normal operation. The color is constantly changing from daylight to brown. As the camera shutter moves across the film, the changing color is captured on the film. The only solution in this situation is to use electronic flash to overpower the available light and provide even illumination.

◼ NATURAL LIGHTING

At outdoor events, light and shadow change constantly. A shooting position at the start of the game could be in deep shade at the end. Stay aware of the shadows. Shooting into shadows and getting the right exposure is difficult for automatic cameras. Shadows will appear much darker in the pictures than they did in person because the human eye automatically adjusts to changing light. Whenever possible, photograph with your back to the sun. This reduces lens flare and lowers the contrast of the image. A balance must be struck between frontal lighting and background distractions. Fill flash may be a good solution if the camera synchronizes a flash at 1/250 of

"At outdoor events, light and shadows change constantly."

a second. Remember though, portable electronic flash units take about five to ten seconds to recharge. To adjust for this, remove the motor drive or set it to single shot. Some flash units provide audible clues for the charge status.

B&W FILM PUSH PROCESSING

When there is not enough light to get acceptable exposures, photographers deliberately underexpose and over-develop the film. This has the effect of making the film sensitivity higher than the rated speed. This is a process called push processing, or pushing the film. To push black and white film, use the developing charts on the next page.

Push processing creates negatives that are difficult to print. Despite the drawbacks, push processing is an option if a flash will create unnatural looking pictures, or if the arena forbids flash. The effects of push processing include:

- increased grain
- reduced grayscale range
- increased contrast
- less highlight detail
- less shadow detail
- reduced sharpness

■ **Note that Kodak T-Max can be pushed to ISO 50000. This speed is suitable for police surveillence work but not for conventional sports photography.**

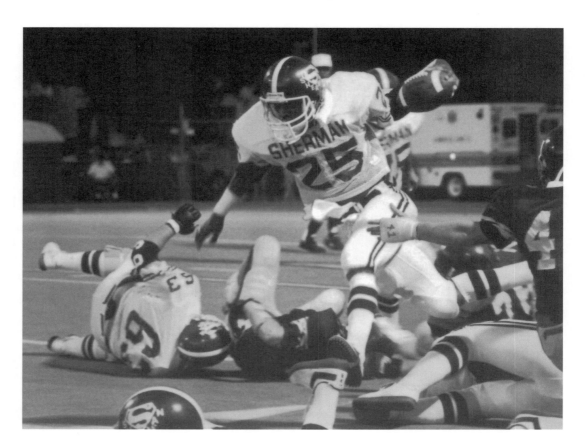

This picture was made on a dim field with an 85mm lens set at f1.8 and 1/250 on ISO 2000 film. This shot shows the exaggerated contrast inherent in push processing. Push processing destroys highlight and shadow detail.

	T-Max 1:4	D-76 stock	HC110 dilution B
Tri-X shot at ISO 1,600	10 minutes	13 minutes	16 minutes
T-Max 400 shot at ISO 1,600	10 minutes	10.5 minutes	8.5 minutes
T-Max 400 shot at ISO 3,200	9.5 minutes	n/r	n/r
T-Max 3200 shot at ISO 3,200	11.5 minutes	15 minutes	11.5 minutes
T-Max 3200 shot at 6,400	14 minutes	17.5 minutes	14 minutes
T-Max 3200 shot at 12,500	16 minutes	n/r	n/r
T-Max 3200 shot at 25,000	18 minutes	n/r	n/r

Time chart for developing push processed Kodak B&W films at 68° fahrenheit

	T-Max 1:4	D-76 stock	HC110 dilution B	Ilfotec HC-D 1:9	ID-11 stock	Microphen stock
ISO 800	8 minutes	9.5 minutes	7.5 minutes	9.5 minutes	10.5 minutes	8 minutes
ISO 1,600	9.5 minutes	12.5 minutes	11 minutes	7.5 minutes	14 minutes	11 minutes
ISO 3,200	11.5 minutes	n/r	9.5 minutes	12.5 minutes	n/r	16 minutes

Time chart for developing push processed Ilford HP-5 Plus B&W films at 68° fahrenheit

Some of the pictures in this book were shot at ISO 2000 using Kodak Tri-X and Diafine developer. Diafine is a two part developer. Agitate the film only once at the start of part A and again starting part B to dislodge air bubbles. Further agitation supplies fresh developer to the highlights causing them to overdevelop so much that the negatives can not be printed.

Practice is necessary to master push processing. Techniques used in push processing vary widely from photographer to photographer and between processing laboratories.

COLOR FILM PUSH PROCESSING

Color print and color slide film can be pushed to double and quadruple ISO speeds by extending the time the film is in the first developer. Over-developing slide film is more common than print film. Most one-hour mini-labs cannot push film at all. Kodachrome films can not normally be push processed because the chemicals that form the dye couplers are embedded in the film, not in the processing chemistry.

Color processing techniques are beyond the scope of the this book.

TRAINING

Photography classes are offered at many high schools and colleges. These are fine places to learn the fundamentals of the craft. They emphasize processing techniques, camera operation, studio lighting, landscapes, still lifes, the nude and other subjects where the photographer has complete control over most if not all aspects of the subject. Sports photographers have little control over the subjects or the working environment. The techniques used in sports photography come directly from photojournalism, not art.

At the college level, art departments often control the photography curriculum. If you are interested in photojournalism or sports photography as a career, avoid photography programs that focus on art photography. Art department instructors are knowledgeable about and interested in fine art and the prestige of exhibiting their work. Photojournalism is treated like a poor relation.

The best training in photojournalism is provided in photo classes taught by journalism departments. The teachers understand photojournalism and respect the goals and methods involved. Frequently the instructors are working photojournalists. [*A list of schools and web addresses appears in the Appendix for your convenience.*]

The best program in photojournalism in the U.S. for many years has been at the University of Missouri at Columbia. Graduates from this program start their careers with better paying jobs and potential for quicker advancement over graduates from other schools.

The National Press Photographers Association offers a series of seminars at several locations every year. Their address and phone number is in the Appendix of this book.

A college education is not required to enter the profession. Most small publications will give assignments to beginners if they have impressive pictures in their portfolio. The

smallest publications will sometimes make assignments just because the photographer has a camera and is willing to work for free or a few dollars per picture. In 1973, the author was paid three dollars for each picture published by the *Eastern Echo*. The *Eastern Echo* is the campus newspaper at Eastern Michigan University in Ypsilanti, near Detroit.

Photographers unable to attend college should read photography and photojournalism books at local and nearby libraries. Study the sports magazines and try to determine how each picture was made. Analyze why the selected pictures were published and compare them to your work. Taking inspiration from other photographer's techniques and picture ideas is an accepted practice.

"Sport lends itself to many photographic styles..."

CHAPTER 5

WHAT TO SHOOT

FEATURE PHOTOGRAPHS

There are opportunities to shoot and sell sports photography at every level, including: pro, college, school, city-sponsored leagues, club leagues, sandlot — even neighborhood children learning to throw a ball.

Sports lends itself to many photographic styles including portraiture, action, photojournalism, fine-art, aerial and landscape. Feature pictures frequently are seen by more readers and remembered longer than action pictures. The potential income from these shots is large, and they may garner more attention than action shots. Alert sports photographers can capture entertaining feature pictures. Dozens of potential shots happen every game. There are always people doing interesting things at sporting events.

PEOPLE

Sports photography includes more than game action. Sports includes everything such as the physics of curve-balls, equipment manufacturing, the politics of public funding for arenas, players salaries, religion and divorce. Photographers may be called on to illustrate stories on any of these topics.

POTENTIAL OPPORTUNITIES FOR FEATURE SHOTS:

- cheerleaders crying after losing the big game
- celebrities
- half-time activities
- injured players being treated
- spectators wearing outrageous clothing
- mascots doing stunts
- players warming up, stretching, chatting or relaxing in the lockerroom
- coaches working with players

There are some very subtle elements which help make good feature pictures of people. These people can either be directly or indirectly involved in sports or sporting events. In the following pages, a few examples of successful shots will illustrate the range and variety of feature pictures that are possible.

The referee on the facing page is shown "drinking" a bag of popcorn between football games in El Dorado, Arkansas. United Press International sent the picture worldwide. Newspapers in Hong Kong, Singapore, Japan and all over North America published the picture. The *El Dorado News Times* published the picture on page one, above the fold, the most prestigious location in the paper. The game photos stayed inside, buried on the sports page.

This image was made with an inexpensive 135mm lens and Kodak Tri-X film pushed to ISO 2000. The photographer stood 15 yards away from the subject. The charm of the moment would disappear if the referee knew he was being photographed. Such feature shots are prizes, and are valuable for the photographer.

A mud football game just concluded and these players are watching the women's game. It is a character portrait of young athletes that tells a story. Though they are not in the midst of it they appear to have been in a battle and were very serious about the competition. A 135mm f2.5 lens was used.

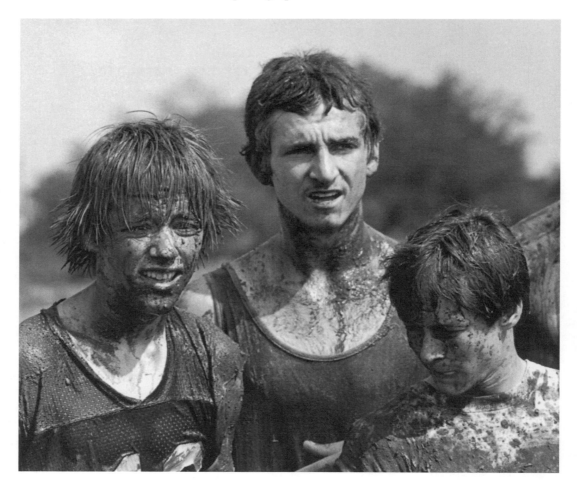

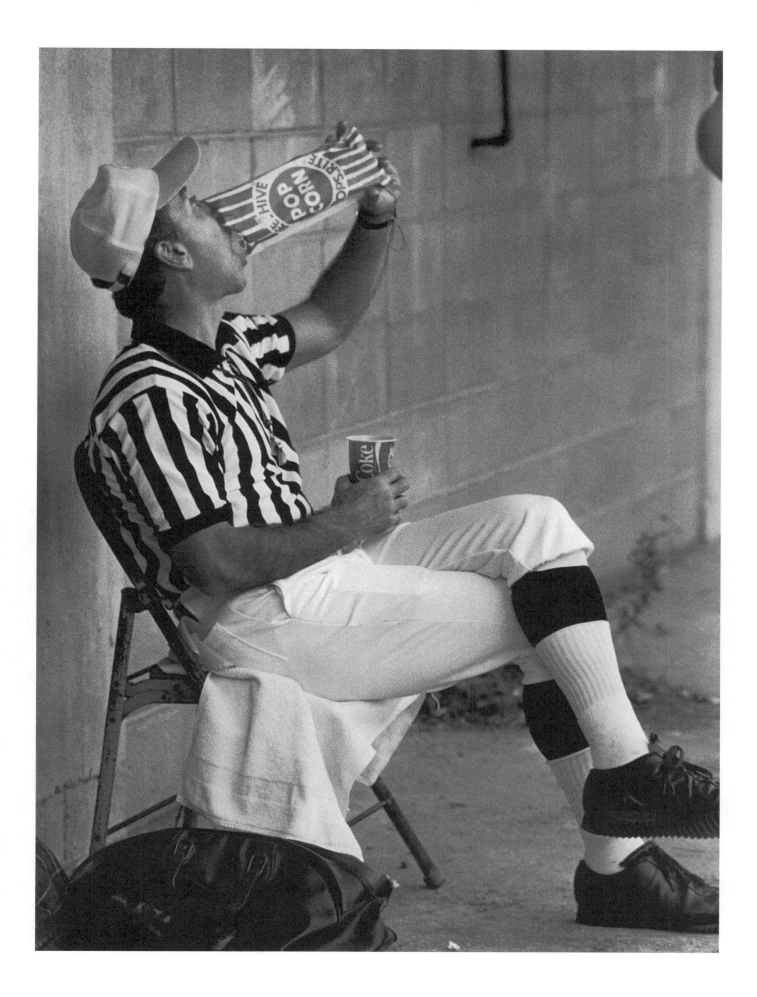

(right) Pep rallies and other sports related events are fertile ground for good feature pictures.

(below) With more than 100,000 fans attending every University of Michigan home football game, hundreds of feature pictures of people are possible.

Strangers and children may request photographers take their picture. It is much easier to shoot one picture than it is to say "no." One shot satisfies them enough to keep them from pestering the shooter. Frequently, good pictures happen.

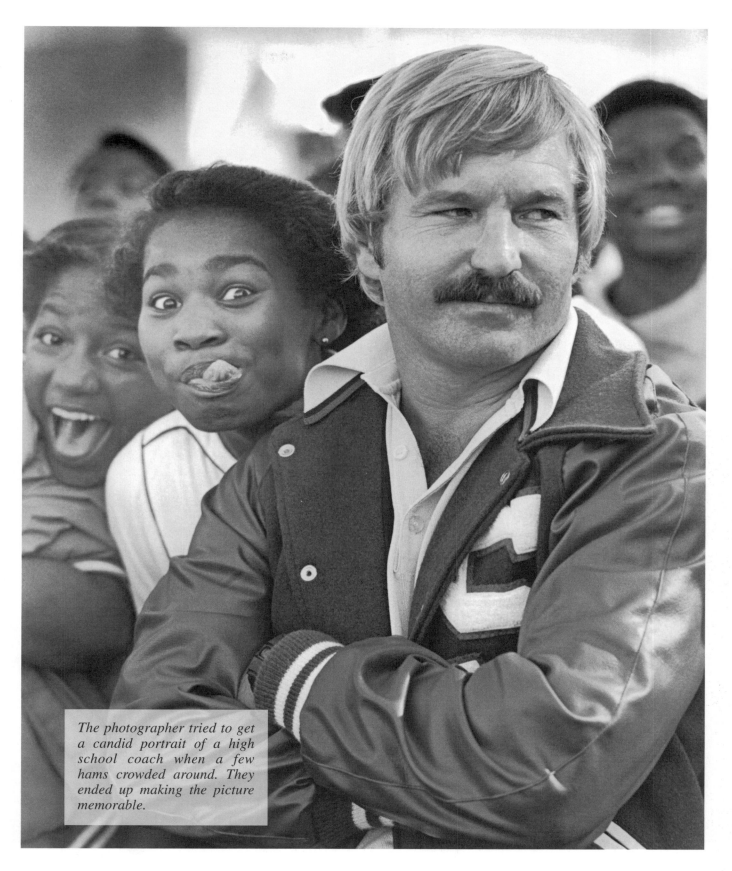

The photographer tried to get a candid portrait of a high school coach when a few hams crowded around. They ended up making the picture memorable.

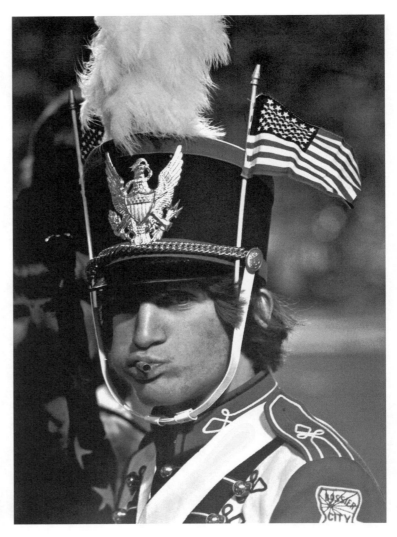

(right) This musician was the only band member to display American flags at the Independence Bowl. It was a very cold winter night in Shreveport, Louisiana where this picture was made. The thing in the musician's mouth is the mouthpiece of his trumpet which he is keeping warm. A good cutline enhanced this picture and completed the story.

(below) Players at an Eastern Michigan University game stand on a bench to get a good view of the plays. Even for football players, sidelines are bad places from which to watch games. However, they are great places for making pictures.

ACTION SHOTS

Though the people surrounding the game make excellent shots, the core of sports photography is sports action shots made during games.

■ INDY 500

At the Indianapolis 500 automobile race the local Associated Press (AP) office controls photo credentials for hundreds of photographers from member newspapers. The AP assigns shooting positions. The AP has runners pick up film from photographers periodically before and during the race. This allows the service to process the film on-site and transmit pictures minutes after they are shot. After a crash photographers must remove film from a camera, even if only a few frames have been cranked-off, so the best pictures, of hundreds shot by many photographers, can be sent to the world's newspapers immediately.

BASEBALL

The popularity of baseball has climbed steadily since its invention. There are baseball fields of some variety in almost every community in North America.

THE PHOTOGRAPHER'S SHOOTING POSITION

Shooting positions for baseball are often limited to either side of the dugouts on the third or first base line, behind home plate, or in the press box of large stadiums. Shooting on the field places the photographer at risk of being hit by foul balls. The chance of being hit is rare enough that most teams and leagues allow professional photographers inside the fence at their own risk. This courtesy may change soon as more liability suits are filed against professional baseball teams by inattentive fans injured by foul balls.

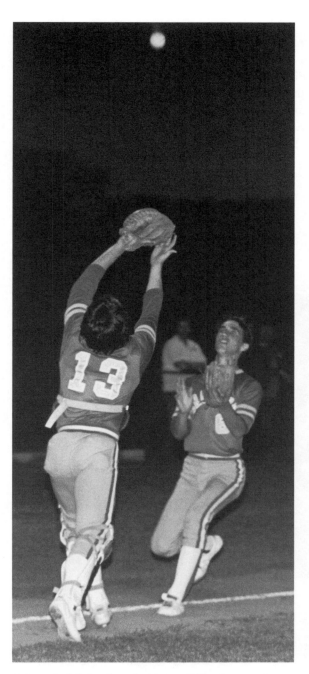

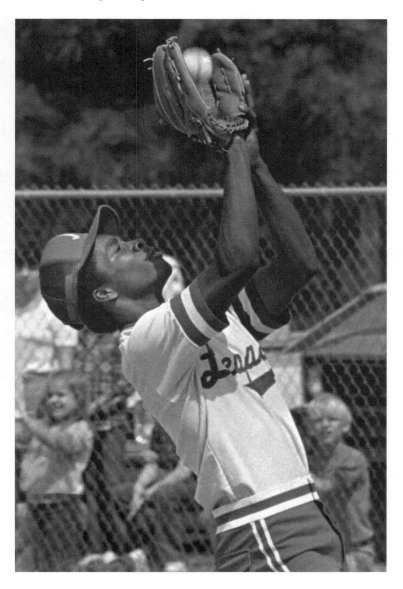

(above) Night baseball is difficult to photograph because of the dim light and the weight of big electronic flash equipment. This pop fly happened on the third base line while the photographer was near the first base line. The print was made using maximum enlargement. A 135mm f2.5 lens was used.

(right) This third base pop fly was much easier to record because it happened in daylight and the photographer used a 200mm lens.

■ PITCHERS

For photographic insurance, shoot pitchers from several angles throughout the ballgame. Lenses as short as 135mm can be used. Pitchers move toward the plate when throwing. Focus where they will be as they throw the pitch, rather than where they stand to take the signs from the catcher. If you focus where they are on the rubber before the pitch, your shots will be out of focus when you try and catch the action.

The depth of field in this picture ranges from the shoulder to the chin. The picture was created using a 500mm mirror lens.

■ BATTERS

Trying to photograph batters is frustrating, time con suming, and frequently fruitless. The ball is traveling too fast to reliably capture the ball hitting the bat. A more reasonable expectation is to have the ball somewhere in the shot. Anticipate the action and squeeze the shutter before the bat and ball connect.

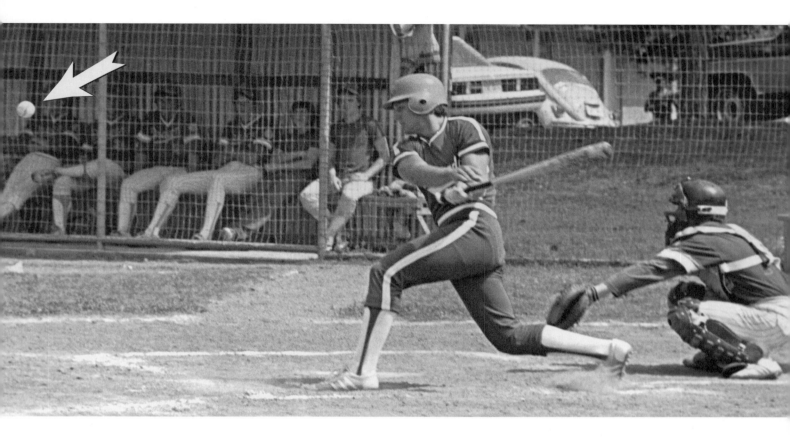

■ FEATURES

Baseball feature pictures can be glorious. They show the flavor of the game in ways action pictures don't. Many of these shots can happen during warmups, in the dugouts, or between pitches when there is really no action on the field. Because there is quite a bit of down time in baseball, there are a lot of opportunities to take features.

(above) A player loosens up in an entertaining fashion before a game.

(right) A coach explains some strategy to a player going up to bat.

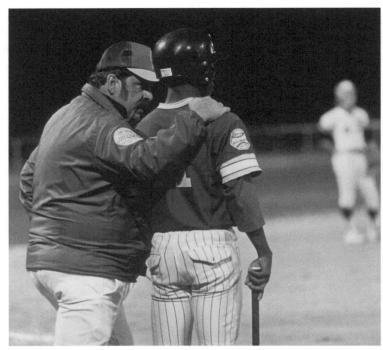

■ OUTFIELD PLAYS

Unless equipped with lenses longer than 400mm, don't bother shooting across the field to capture a play deep in the outfield. Can you see the ball in the shot to the left? It is there as a half moon speck lost in the player's glove. This picture was shot with a 300mm lens.

■ PLAYS AT FIRST

Plays at first are easy to capture with a 135mm lens because photographers can get within 20 or 30 feet. A common shot — that is easy to get — occurs when a batters hits a groundball to an infielder with no one else on base. The fielder throws to first to get the batter out (see below). Another play at first is a pick off, where pitchers try to pick base runners off who have too big of a lead toward second. Runners may dive back to the safety of the base to avoid being tagged out. With runners on, some pitchers will throw to first base repeatedly to keep the runners close to the base.

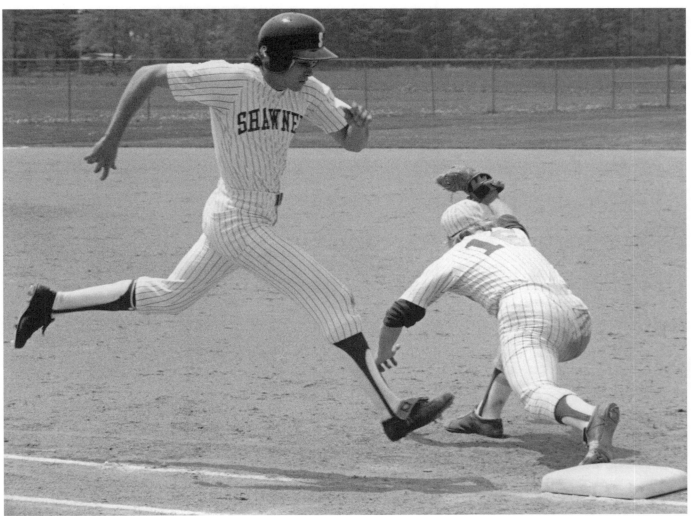

(right) The first baseman fields a throw from the pitcher in a failed attempt to pick off the runner.

(bottom) This runner discovered the best way to slide into second is between the opponent's legs.

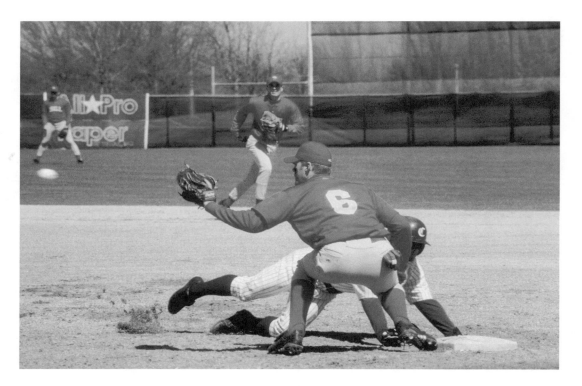

■ PLAYS AT SECOND AND SHORTSTOP

Plays involving the second baseman and the shortstop require lenses in the 200mm to 400mm range, depending on the photographer's shooting position on the sidelines. Fielding errors and runners attempting to steal second are good picture opportunities. At night these plays are out of range of most flash units.

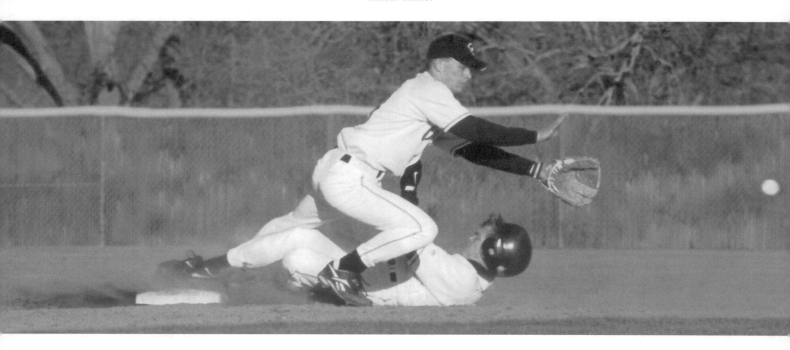

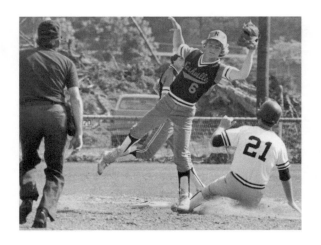

(above) *A close play at third base was shot from near the first base line with a 300mm lens.*

(right) *One way to reach home is to leap over the catcher. A 200mm lens was used.*

■ PLAYS AT THIRD

Plays at third are covered just like plays at first but from the third base line. From the first base line, a 300mm or 400mm lens is necessary. These shots are out of range of flash units from the first base line.

■ PLAYS AT HOME

The payoff for baseball photographers is the close play at home or a celebration after a run scores to win the game. This is the "Home Run" of baseball photography. Lenses in the 85mm to 300mm range are perfect depending on the photographer's distance from the plate. This is an ideal opportunity to use a zoom lens.

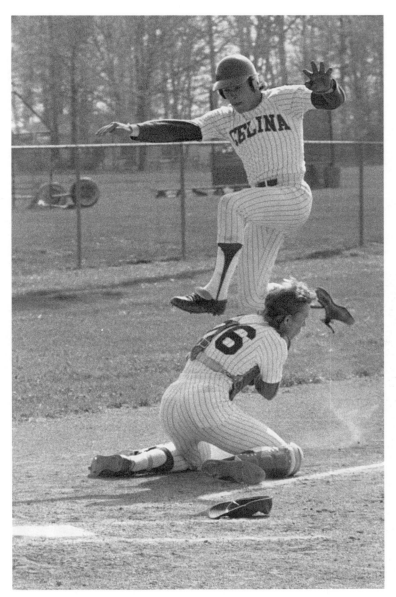

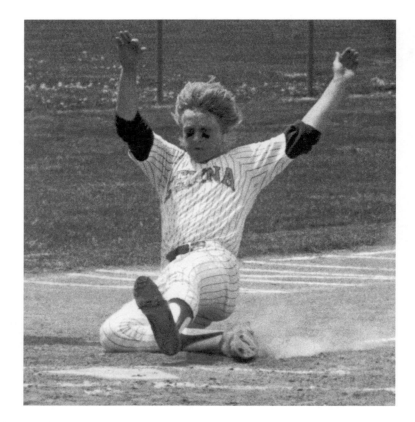

(right) A runner is safe during a slide into home plate. This image was shot with a 135mm lens.

(below) A runner stomps on home plate with the winning run and a victory celebration erupts. A 50mm lens was used.

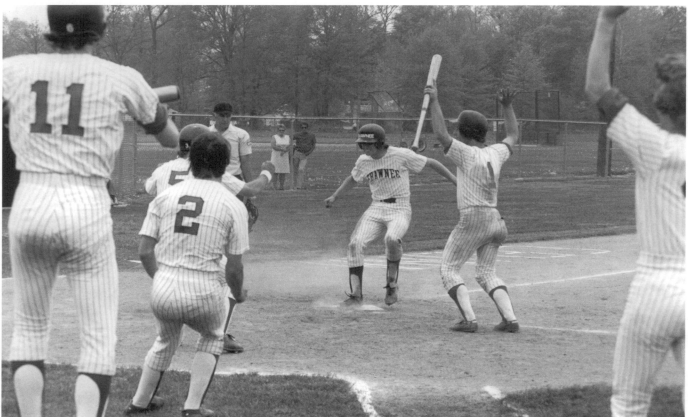

■ BASEBALL SAFETY

Compared to football and rodeo, baseball is quite safe. The only real dangers come from being hit by baseballs, bats and beer bottles. Use the dugout and other ball park structures to protect yourself and your equipment.

■ CYCLING

Competitive cycling events provide different opportunities for photographers. Useful lenses range from 50mm to 200mm. In cycling the crowd is kept a foot off of the road by temporary fencing. Races can have hundreds of riders. Riders tend to stay bunched together in groups. As with other sports, feature photos add perspective to the event.

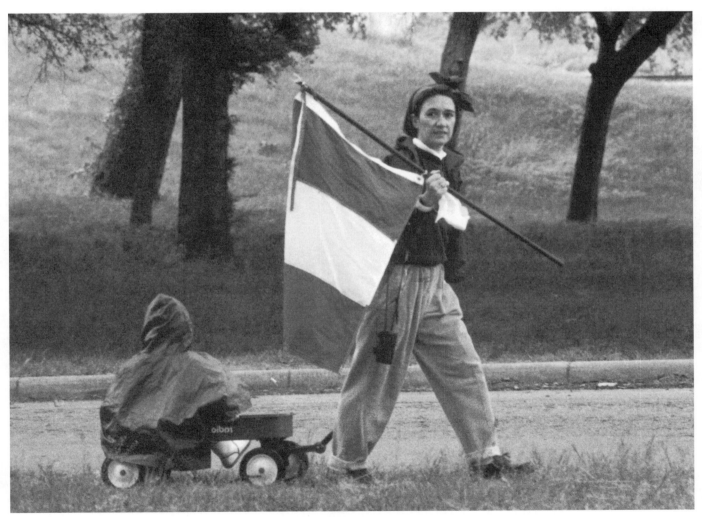

A woman pulls a child to watch and cheer riders in a bicycle race called a Criterium. Bicycle racing is huge in Europe and growing in popularity in the United States. In the U.S. the popularity of cycling has been cyclical since the 1880s. At one time attendance at bicycle races was greater than football games.

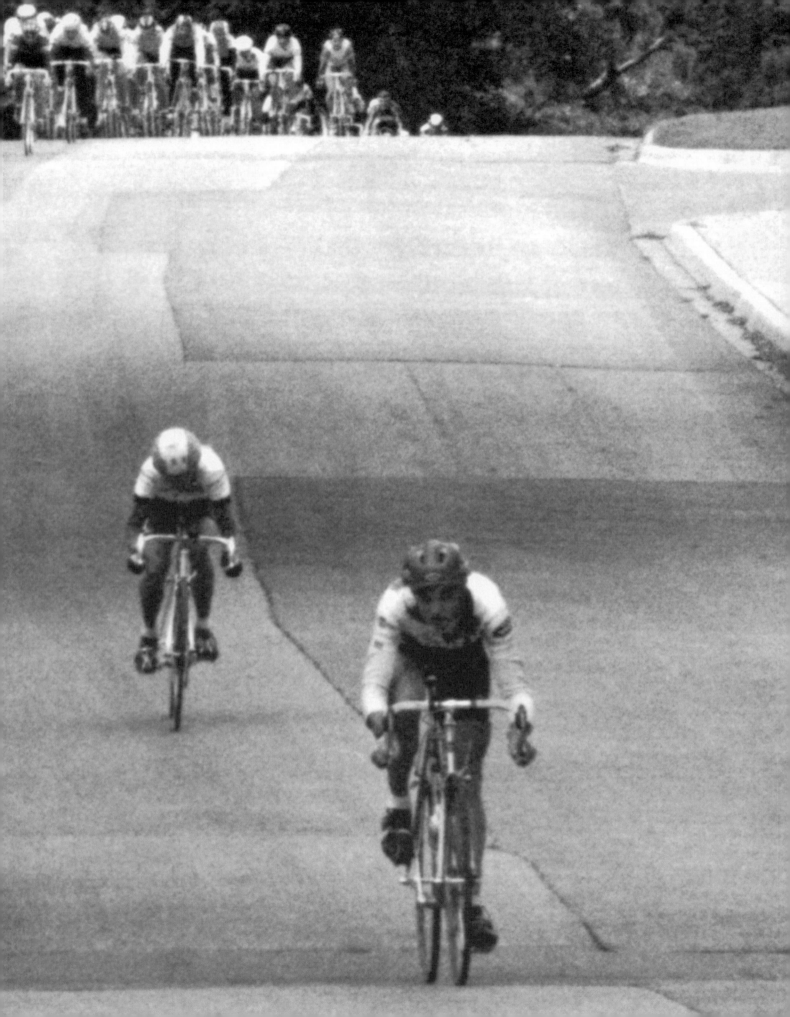

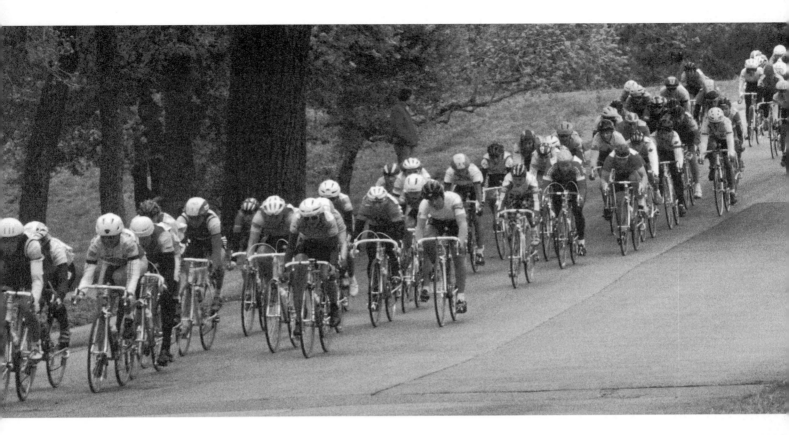

Bicycle races lend themselves to a landscape style of photography. Some of the pictures use the racers as an element in landscape style photography. Every year photographers at the Tour de France picture the racers riding through the countryside. Sometimes it seems the French sunflowers are the subject of the pictures and the cyclists are just the excuse to publish the sunflower pictures.

(left) Two cyclists pull away from the pack. The leading rider is more than 50 yards ahead of the pack. A 200mm lens compresses the apparent distance.

(above) A 135mm lens was used to capture the racers in a wide landscape.

(right) Allowing the riders to blur over a sharp background helps tell the story of this race; riders averaged 27 mph.

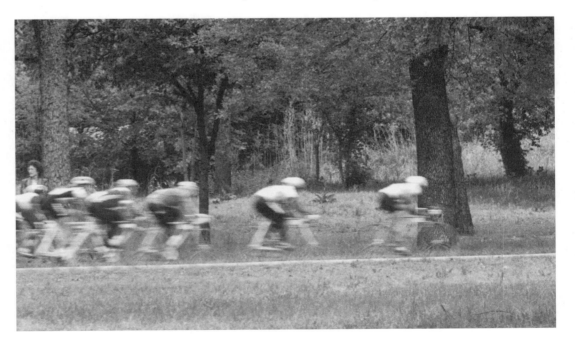

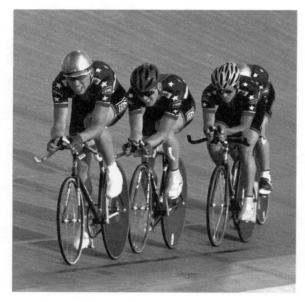

(above) The 300mm setting on a zoom lens was used to show how close together the EDS cycling team rides on a velodrome. The closer they ride the less wind resistance the trailing riders face.

(right) The U.S. national team starts a turn. The aerial view creates a graphic image because the lines on the track become part of the design.

■ BICYCLE RACING

There are about 15 Olympic cycling events that take place on a velodrome. These oval tracks are banked up to 45 degrees so racers can achieve speeds over 40 miles-per-hour. As of 1998 there were more than 700 velodromes around the world, only 15 in the United States.

Shooting from above the track gives a graphic perspective to the pictures. The emphasis is on shapes and lines. Shooting from the infield allows the photographer to show faces and the intensity of the competition. Lenses ranging from 28mm to 500mm can be used effectively.

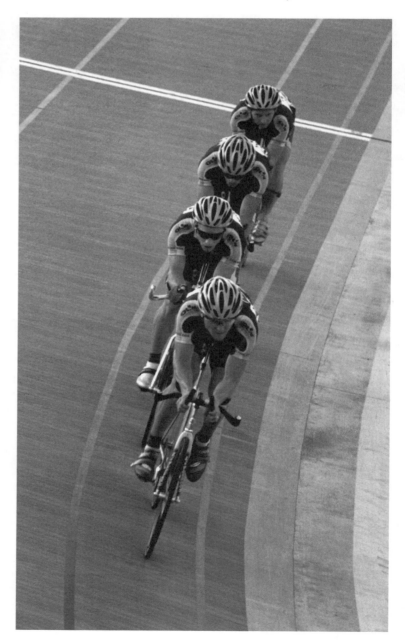

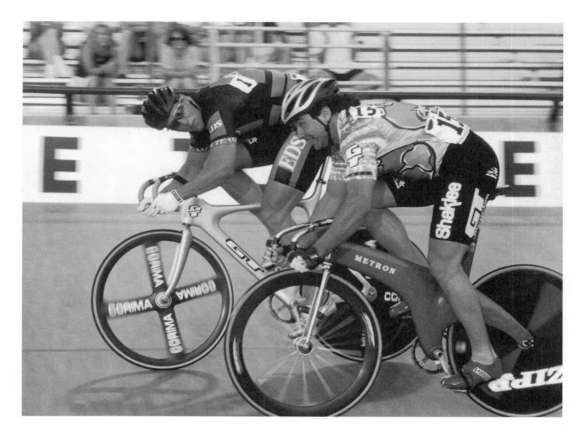

(right) The leader in a match race checks his competition just 20 yards from the finish line.

(below) This team displays perfect form. Shot with a 300mm lens.

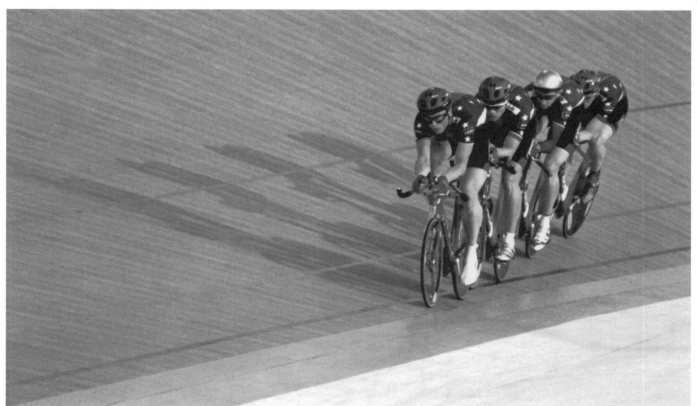

■ **RODEO**

Rodeo is among the most dangerous of American sports. Bad lighting in evening rodeos forces photographers into a difficult choice. Shooting the action with a flash would cause ghost blurs as a side effect of a synchronizing speed of 1/60 of a second. The other choice is ISO 1600 slide film. The 1600 speed film is very grainy and gives a gritty soft focus look.

Note how similar the position of bronco and cowboy is to the logo on the wall. The ISO 1600 slide film used to get this picture gives it a dark gritty look that is appropriate to the sport.

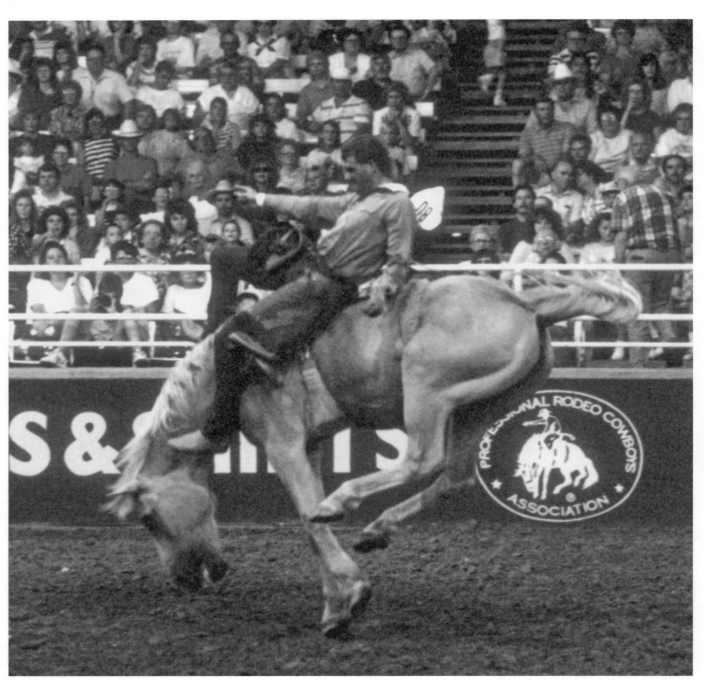

■ FOOTBALL

Football is the most frequently assigned subject for sports photographers. The demand for pictures of game action and associated activities is astounding. Newspaper photographers could shoot five games a week. Covering two different high school games on a single Friday night is common. Some photographers specialize in football pictures and make successful careers shooting related pictures year round.

Football places high demands on photographers. It demands physical endurance, technical photographic skill, and basic knowledge of how the game is played.

An Oklahoma State University quarterback steps back into the pocket to complete an option play. A 300mm lens can be used to capture this common scene.

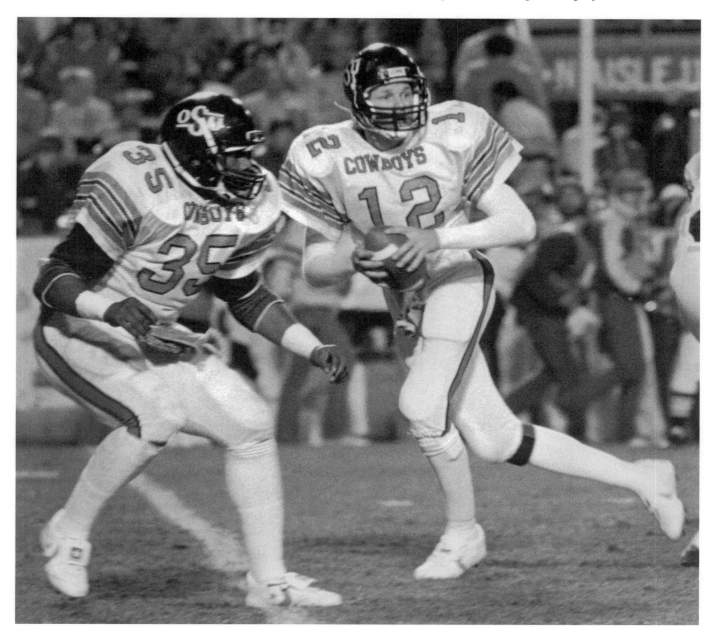

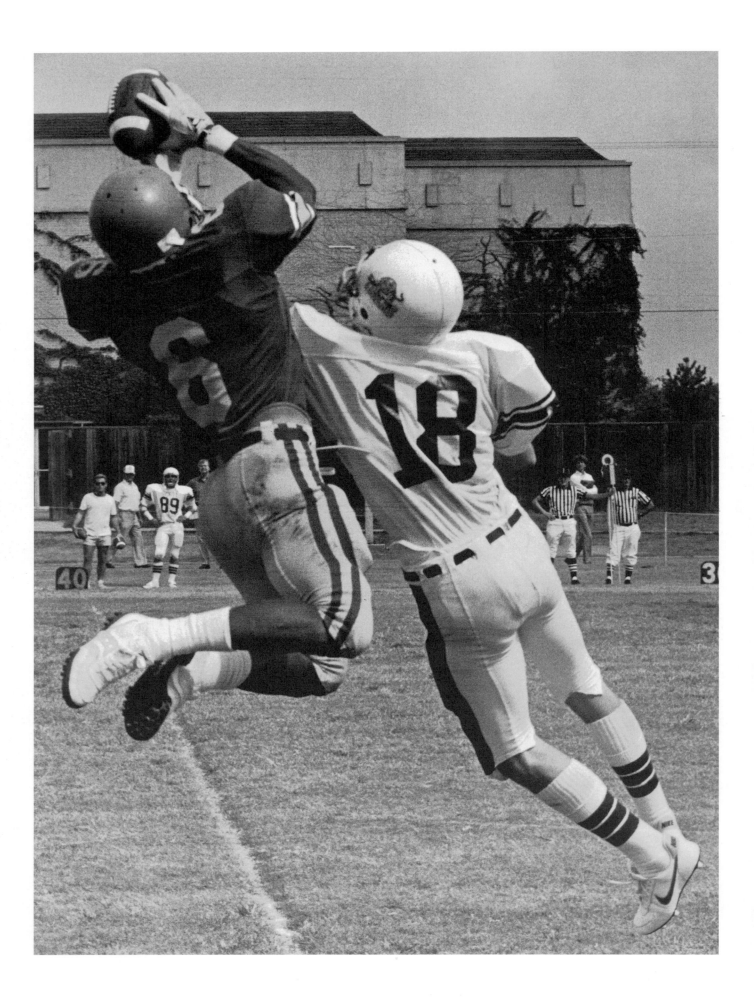

(left) This shot of a receiver leaping for a pass displays perfect photographic timing. The primary flaw is the players backs are to the camera. Since sports photography is about people, pictures which show faces are more interesting. Also, the background is too sharply in focus.

(below) The picture editor cropped this shot, eliminating most of the image. Half a dozen players were cropped out of the picture. Their presence did not contribute to the storytelling power of the image. Removing unnecessary players simplifies and improves this picture.

■ THE 40 YARD ARC

The 80-200mm zoom lens is effective 10 to 20 yards from the photographer. Action closer than 10 yards is tough to follow through this lens. Plays beyond 20 yards yield too small an image on the film to print well. This gives the photographer using an 80-200mm zoom lens a coverage arc 40 yards wide.

Action in the center of the field, or beyond the 40 yard arc, requires a 300mm or 400mm lens. Plays on the far side of the field are out of range of lenses shorter than 500mm, but can be enlarged in a darkroom or by computer. Results are grainy and often out of focus.

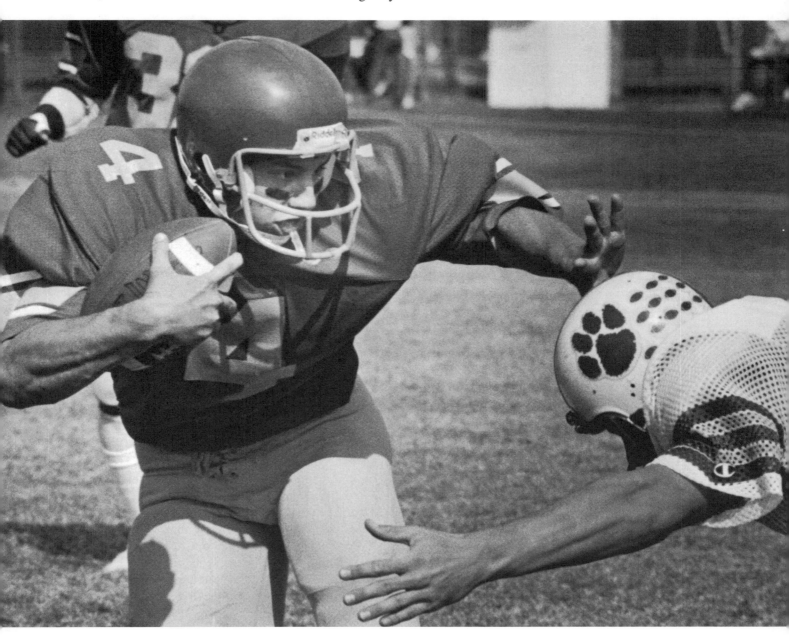

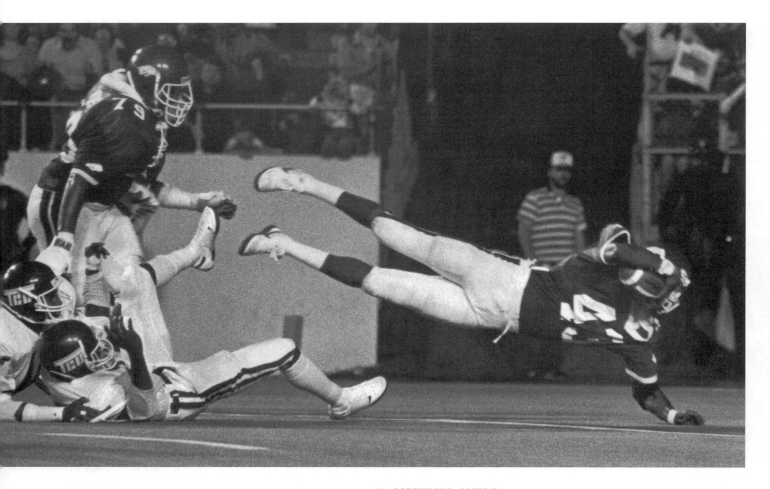

(above) *This picture of an Arkansas Razorback scoring a touchdown shows the winning play. The player leaped over the Texas Christian University defenders to score. Along with the importance of the play, this is an interesting peak action picture because of the odd position of the runner and because the ball is visible.*

(far right) *A defenseman jars the ball loose by colliding with a receiver just as the receiver is trying to catch a pass.*

■ **CAPTURING ACTION**

Common football action that you will want to capture includes a runner crossing the goal line, a receiver the instant before the ball is caught, a player making or recovering a fumble, a kicker as his foot impacts the ball. The goal is usually to freeze the instant in time: the texture of the jersey should be clear, at least one face in sharp focus, and nothing blurred. Because of delays in human reaction time, and the mechanical processes of cameras, the shutter button must be pressed before peak action happens in order to capture it. Every camera has different reaction times. Practice is necessary to achieve good timing.

The other extreme in illustrating action is taking shots that are intentionally blurred. The blur of the players moving quickly conveys the sense of motion in a still image, and in some cases can accentuate or enhance the action. Though freezing the action is preferable in most cases, you may want to try a few intentionally blurred shots per game. However, don't do it during plays that have the potential of being pivotal in the game. Experiment in less dramatic moments.

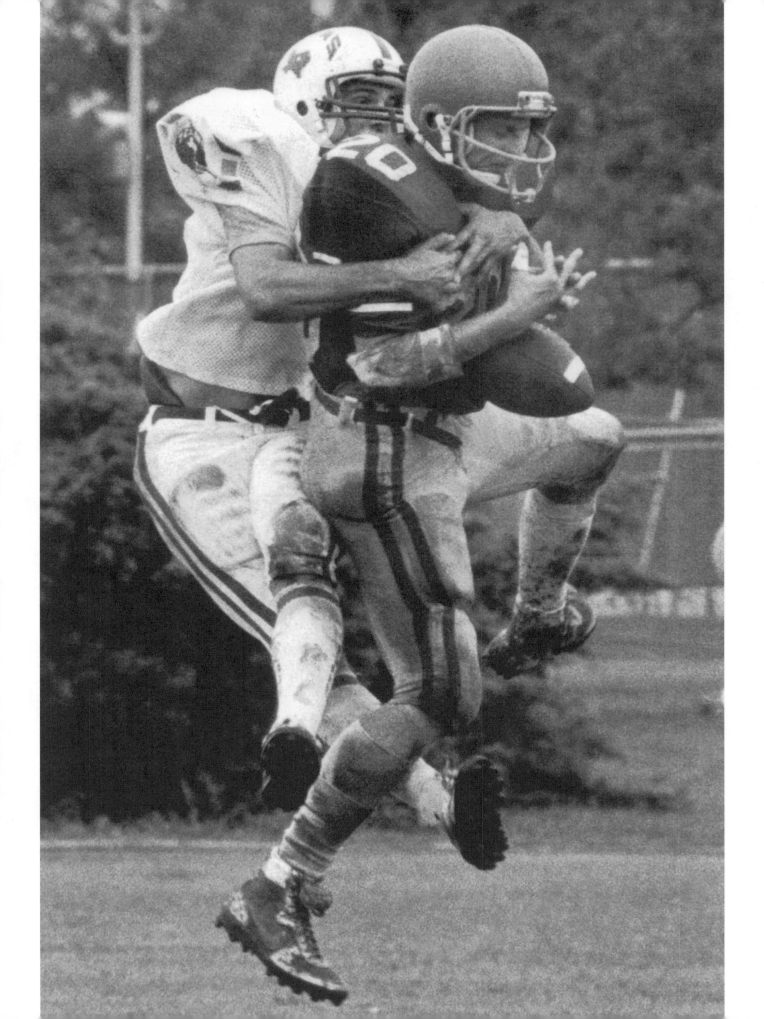

In almost every play a quarterback takes the ball from the center and steps back a few yards before implementing the plan. Shoot a few of these shots at the start of the game as photographic insurance. If none of the planned pictures work out, at least something will be publishable. Do not settle for this type of shot alone. Stretch your skills and try for more exciting pictures once the insurance pictures have been acquired. The more spectacular your shots, the better your reputation becomes and the more money you make.

An insurance shot of the quarterback dropped back and ready to throw. It is a good all-purpose shot of action about to happen.

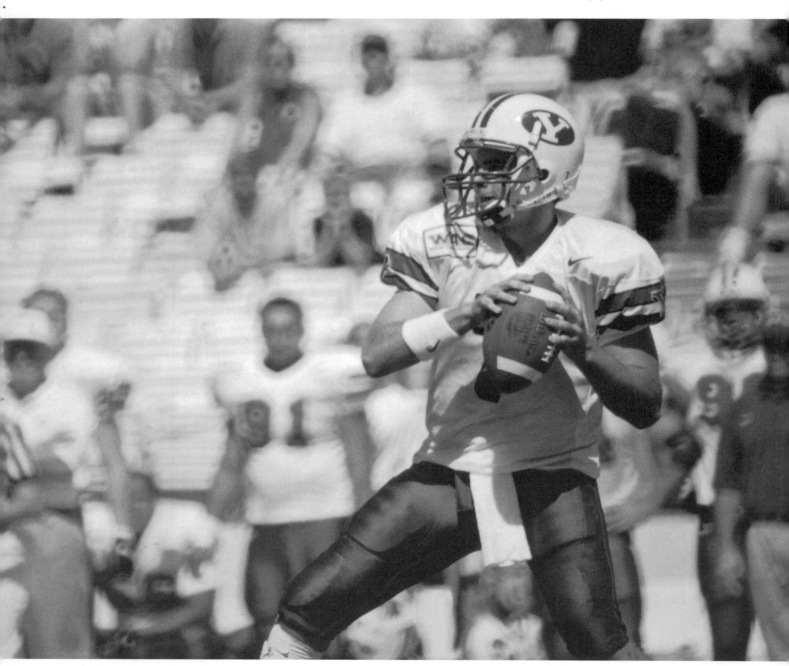

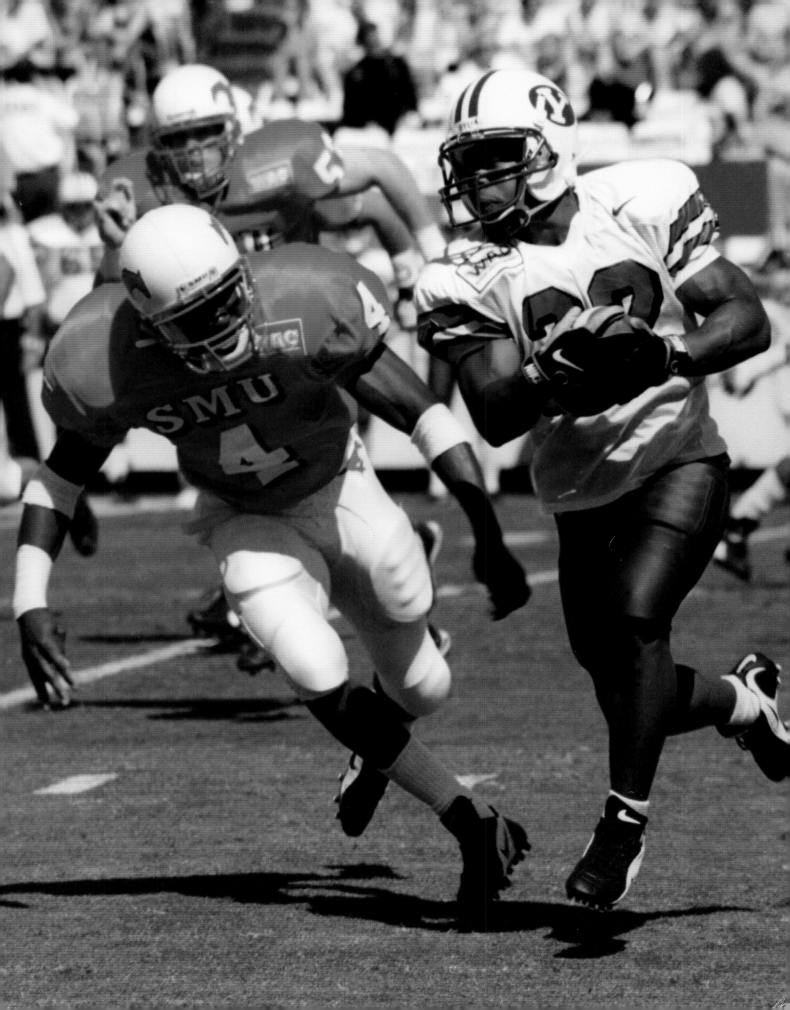

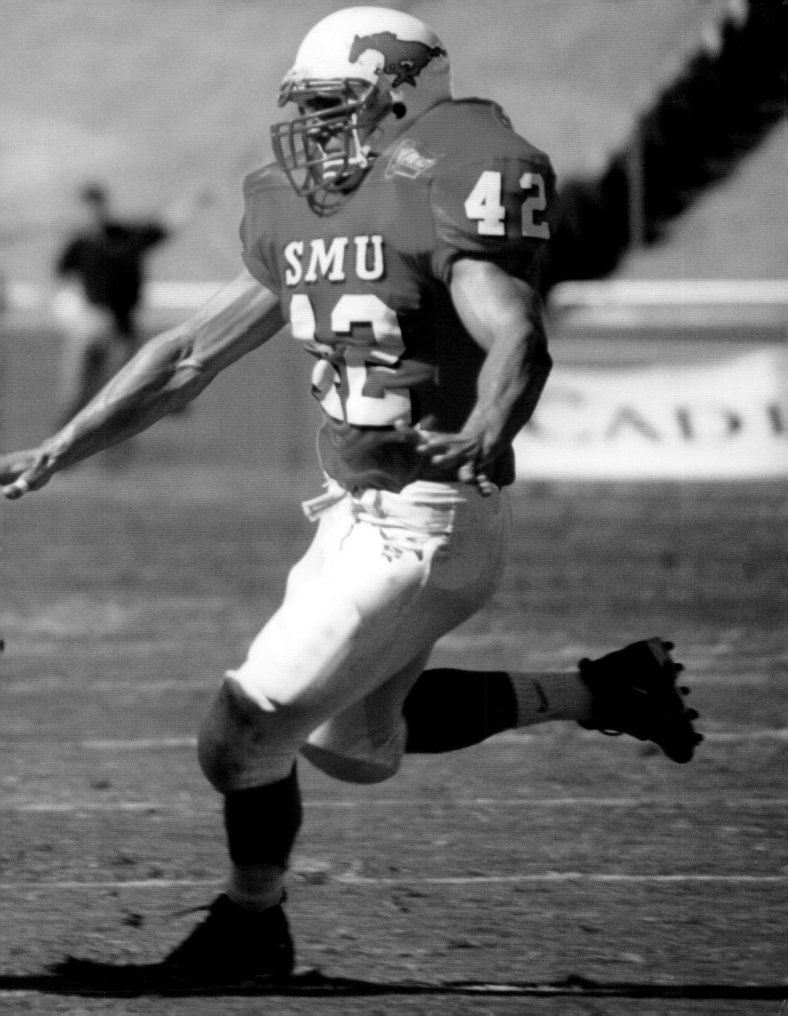

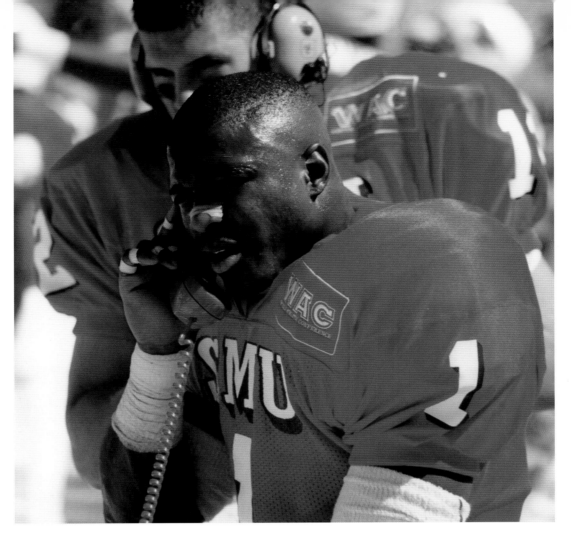

(right) A football player from SMU talking via telephone to coaches in the press box is an interesting picture. Add the red glow of a sunset to the players red uniforms and color becomes the dominate element in this shot.

(below) The yellow of the Texas A&M team uniforms is enhanced by the glow from the sunset at the stadium.

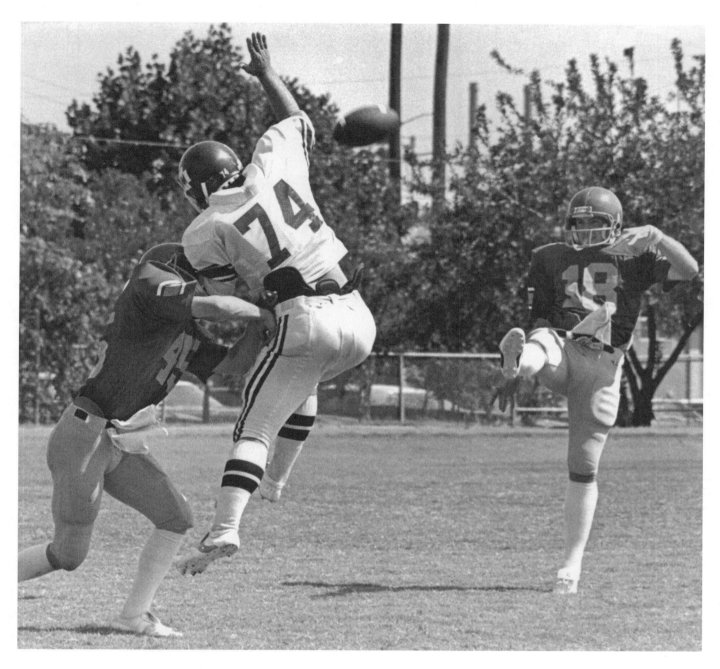

A blocked punt can be a disaster for the kicking team. This play took place across the field, and was shot with a 200mm lense at f8. A better lens choice in this situation is either a 300mm or 400mm because of the greater magnification they provide.

Always shoot your team's defensive and offensive plays. Both halves of the team contribute to any victory and must be photographed. If the hometown team is playing offense and fumbles the ball, the photo may be unpublishable even though it is a significant. Many small newspapers and school publications fear offending readers. If the hometown team is on defense and the other team fumbles, the shot may be very desirable, especially if the fumble leads to a winning touchdown.

This is an example of a pass shot that loses its impact because of inattention to the background. Shot with a 200mm lens at f11, the picture has so much depth of field that the background is in focus. The shutter speed was 1/250 of a second. The background would have been less noticeable if shot with a 1/1000 shutter speed and the lens opened up to f4.

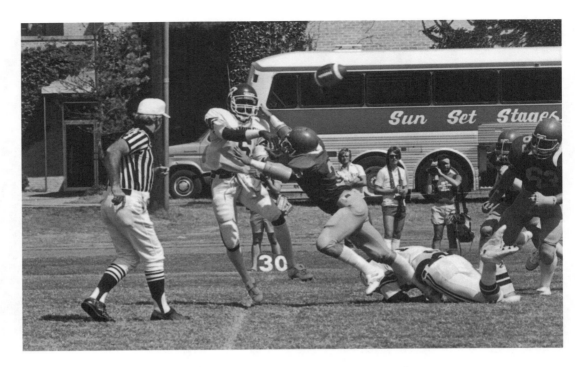

Backgrounds make or break shots. Richard Schwarze, a school photographer at Eastern Michigan University in Ypsilanti, says he always shoots day games from the east side of the field until the shadows get too long later in the game. The home crowd sits on the west side of the stadium. His pictures show the stadium filled with fans, which is part of the image the school wants to present to the world. The visitor's side of the field rarely has more than 2,000 spectators.

Here is an example of the situation Schwarze works to avoid. The background of empty seats detracts from the picture. If the photographer shot from the visitor's side of the field, the home town crowd would be in the picture, thereby adding a big time football atmosphere to the image.

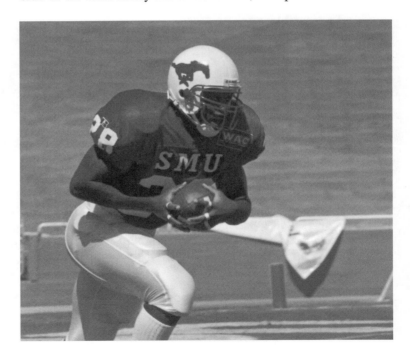

(right) Defenders about to pounce on the quarterback as he releases a pass. A dramatic high action shot.

(below) Following the ball, through a camera lens, is an essential skill to master. In doing so, photographers frequently capture pictures of violations that referees miss. Referees cannot see everything, and they don't use cameras to magnify and freeze the scene.

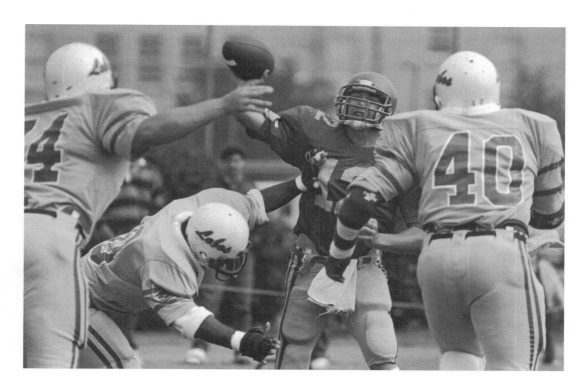

■ STAR PLAYERS

Photographing star players is easy. Take a position ahead of the line of scrimmage, and in the viewfinder follow every step the subject makes. Anticipate the action and snap before it happens.

■ BASKETBALL

In the 1980s basketball became a trendy sport in North America. News coverage of the personalities, salaries, and controversies quickly eclipsed coverage of National Basketball League games. But, at the school level, game stories were still important.

No sport is easier to photograph than basketball. But it should also be noted that no game is filled with cliché pictures like basketball.

A forward dribbles toward the basket as he prepares for a lay-up.

The most common basketball action shot is derisively called "The Armpit Shot." An armpit shot is a picture, taken from under the basket, of a player jumping to make a shot. The player can be under the basket, dunking the ball or shooting from 10 to 15 feet away. The unifying feature is the sweaty armpit in the center of each picture. Armpit shots can be made with any camera with an electronic flash. Even disposable cameras can make armpit shots.

Every child in this picture could take a successful armpit shot with his camera if given the chance at an outdoor day game.

This is a typical armpit shot. They are so easy to shoot it is tempting to shoot nothing else. Don't give in to the temptation; better pictures are just a little more difficult to achieve.

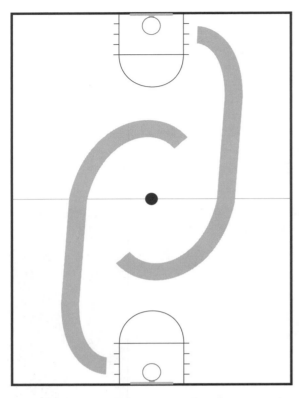

(above) The shaded areas in this diagram of a basketball court illustrate the running path occupied by the two officials that referee at organized games. Shoot from the right side of the basket to avoid getting the official's fanny in every shot.

(right) A jump ball was used as an opportunity to show the scoreboard. The scoreboard helps tell the game story for the readers.

Photographers congregate under and to the right of the basket, and shoot each attempt to score. After taking a few armpit shots as insurance, the skilled sports photographer will concentrate on the more difficult picture opportunities elsewhere on the court. The most useful lenses are a 50mm *f*1.8, and a 85mm *f*1.8.

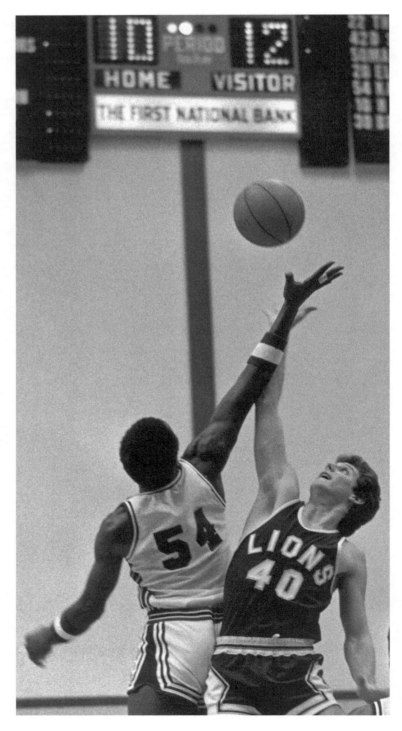

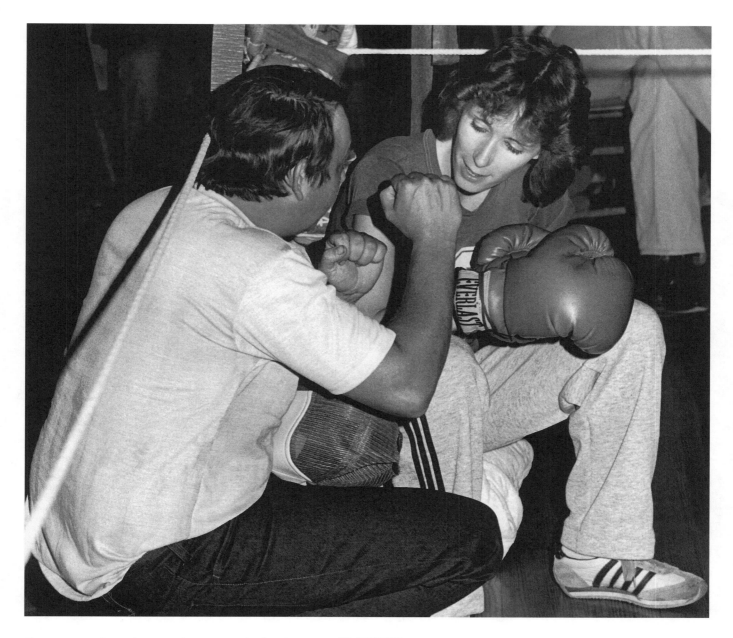

Strategy and tactics are important in boxing. This picture of the coach giving the fighter pointers and encouragement show the seriousness and intensity of the women's contest.

▧ BOXING

Professional boxing is very popular with television networks because of its violence. But boxing is very rare as an amateur sport. Even rarer is women's boxing.

This image on this page was shot at a series of matches staged as a fund-raiser at a small town in southern Arkansas. *The El Dorado News Times* sent two photographers to document the event. All the pictures were shot with 28mm and 50mm lenses. The photographer shot between the ropes so she would not be seen. This picture displays conflict, action and emotion, all important elements in successful sports photography.

■ SOCCER

Soccer is a fast moving game played on a field significantly larger than an American football field. Play does not stop unless the ball leaves the field, a penalty is assessed, or someone scores. This continual activity demands a sports photographer be alert and focused on the play throughout the entire game. The ball can move from one end of the field to the other in seconds. Most of the plays, however, are centered on the middle third of the field.

A high school player in Texas appears to fly through the air in pursuit of the soccer ball. A 135mm f2.5 lens captured this shot at 1/500 of a second on Tri-X film pushed to ISO 2000.

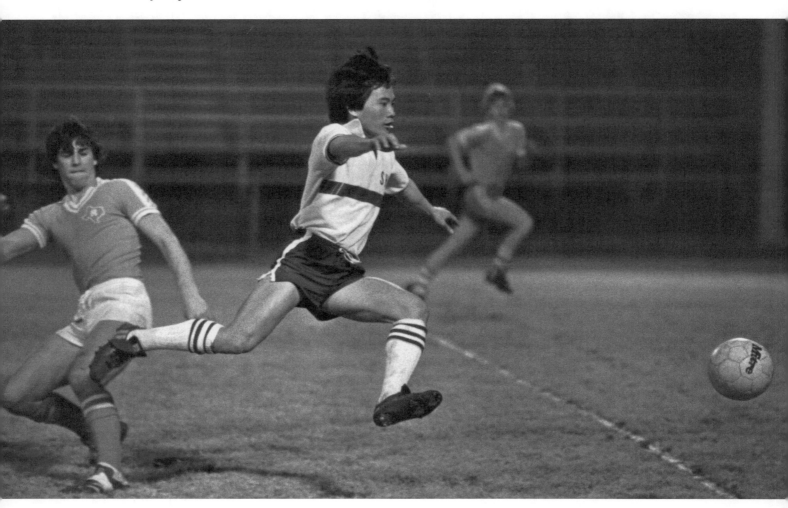

A well-equipped photographer might use an 85-300mm zoom, a 400mm, 500mm or even a 600mm super-telephoto. Multiple cameras and high-speed motor drives (three to ten frames per second) enhance the probability of capturing peak action.

Desirable pictures include players colliding, tumbling, or fighting. Also good are shots of players knocking down the ball, players bouncing the ball off their heads, and guiding the ball with their feet. To get shots of scoring attempts, stand on

In soccer parlance this is called a "header." The players appear to be a yard above the ground. The picture was shot with an 85mm to 300mm zoom set to about 200mm.

either side of the goal and follow focus the play. This is a high-risk location compared to sidelines as the games are usually low scoring. Some games end 0-0, many feature less than five goals scored between both teams. Capturing a goal or a save can produce a significant picture.

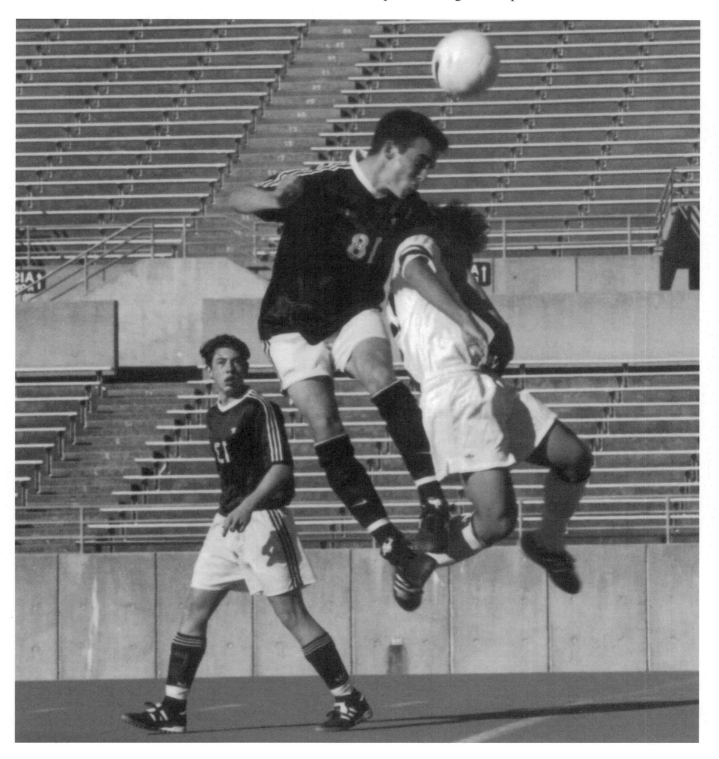

Outdoor fields are crowned to drain off rain water. As a consequence, the center of the field may be two or three feet higher than the edges. Photographers standing on one sideline may note that the bottom half of a player, on the far side of the field, disappears from view. Because of this, and the weight of super-telephotos (600mm and longer), some published pictures of game action are shot from the photo-deck or the press box. This is a great way to get the action but a poor way to show the human drama and emotion.

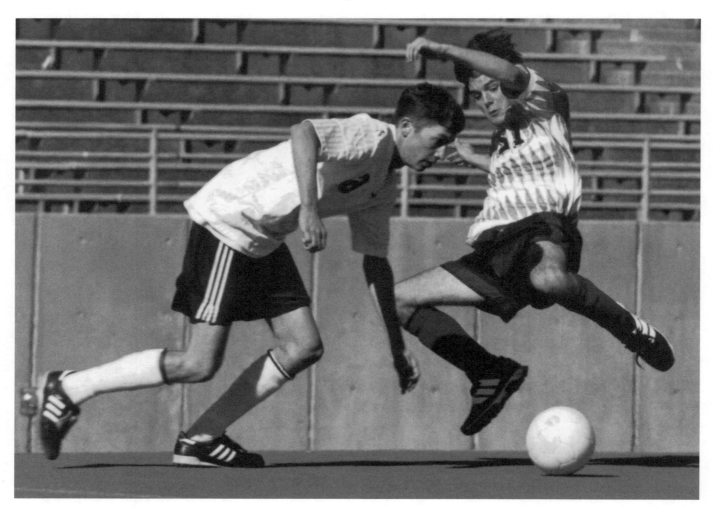

The author likes pictures where one or more players appear to be in mid-aid. These pictures show the drama of the sport well. This picture was made by a 300mm lens.

High shutter speeds (1/500 of a second or faster) freeze the action in mid-air as many of these pictures show. Players forever locked in mid-jump are especially fascinating.

Young players are still learning ball control, so if a portfolio picture is needed, photograph high school or college players. Women play a different style of soccer. The games tend to be somewhat less physical than men's games, so their pictures come out differently.

■ HOCKEY

Hockey poses unique problems for sports photographers to overcome. First, the highly reflective ice will cause false exposure readings. Consider taking an incident light meter reading from ice level before a game. Second, the plastic barriers that protect the fans from pucks and sticks are too marred to shoot through. Find a position high enough to shoot over the boards. Often the best place is the television deck or the press box. Finally, the puck is exceptionally difficult to follow. Only practice will improve puck tracking. Consider photographing only the fights and the victory celebrations until tracking skills improve.

Hockey is a violent sport. This collision of Michigan and Notre Dame players resulted in a penalty. A 135mm lens was used and the image was greatly enlarged.

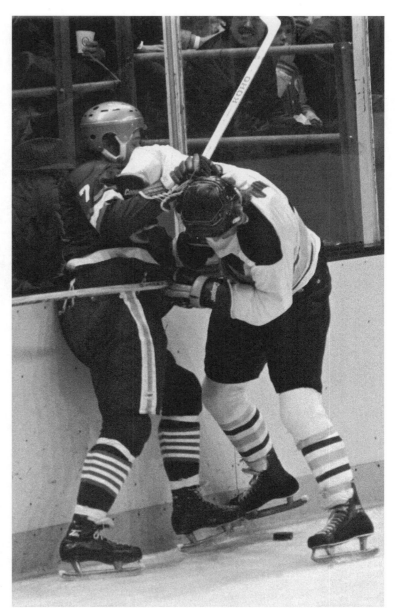

TENNIS

In many ways tennis is similar to hockey for the photographer. The fencing that protects the audience blocks the photographer. Shoot over the fence if possible. Tennis players switch sides after every set, so photographers with a good perch can stay put and get shots of both contestants. Shooting from court-side often fails because of the difficulty of following a player as he runs all over his side of the court. The ball moves too fast. An elevated position works better.

Action pictures in tennis tend to look similar. Consider using a slow shutter speed for a blurred motion effect, or focusing on the emotional scenes. Some players get angry and do unusual things like yelling at fans and officials, or throwing their rackets. These scenes are fair game for the sports photographer. Some athletes will stage a scene just for the publicity it gains them.

The intensity on his face and the tension in the arm and leg muscles make this a memorable tennis photo.

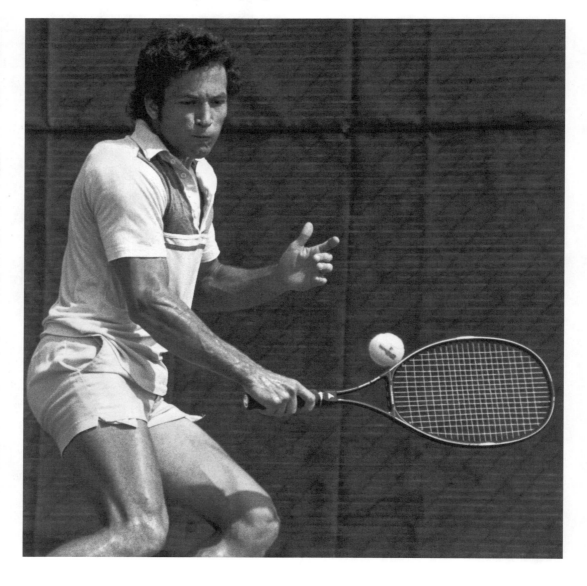

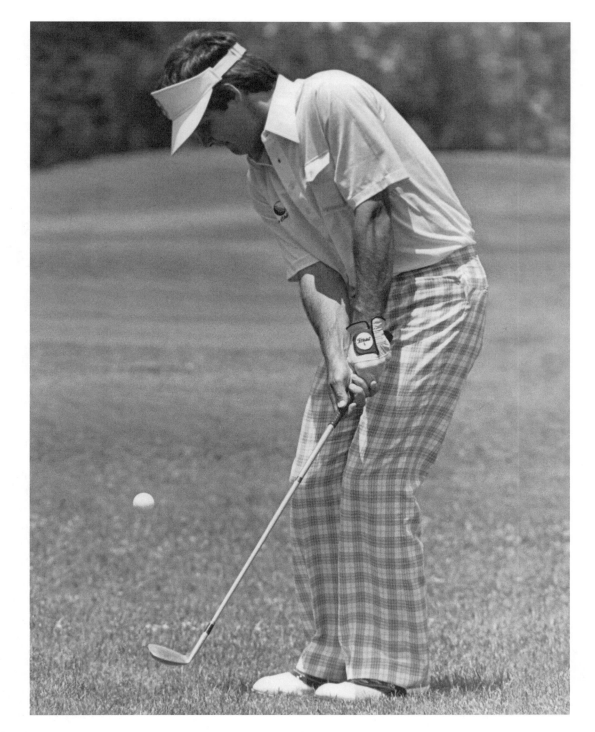

In the early 1980s this golfer posed for this picture and made the same shot a dozen times to assure that the ball was visible in the picture. Posing pictures is ethical if the caption does not claim the pictures were taken during actual play. A 400mm lens was used.

■ GOLF

Quiet cameras and long lenses are necessary to photograph golf. Players are easily disturbed and distracted by noisy equipment and photographers. A 200mm lens is a minimum lens for tournaments, 400mm and 500mm is better. If a golfer consents to pose for pictures, then any lens can be used.

■ SWIMMING

A special consideration for photographing swimming is the high humidity at indoor pools. Arrive 30 minutes early so the vapor that condenses on your tools can evaporate as the cameras and lenses warm up. Safety is also a big issue at pools. Wear shoes with deep treads so you don't slip on the wet deck.

The intensity of effort this child is making illustrates that expressions count even in action shots.

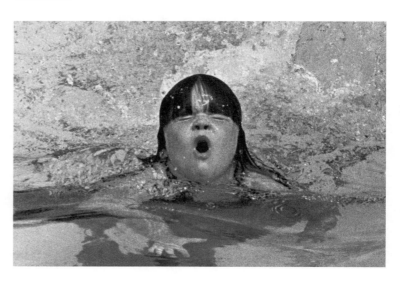

■ DIVING

A picture of a woman diver with her fingers just entering the water once ran on the front page of *The Daily Standard* in Celina, Ohio. The caption said something about testing the water. The diving coach was very upset the paper ran the picture because the athlete's diving form was poor. She had no appreciation for the exquisite timing and humor of the shot. The lessons are: don't play games with the cutline, and don't choose an inferior performance to get a superior picture.

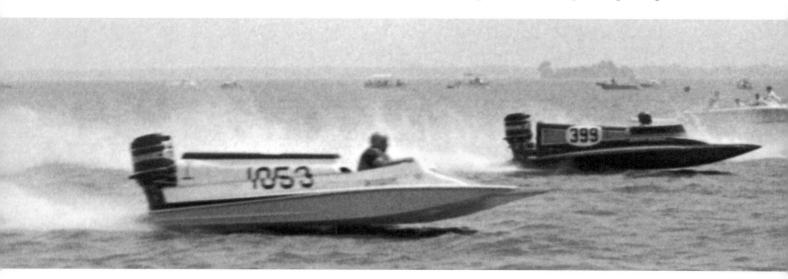

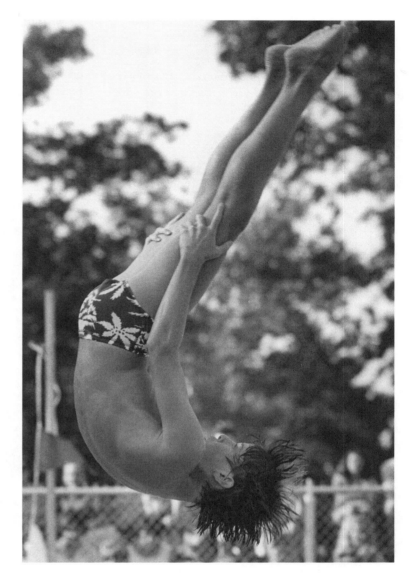

(right) This diver shows better form than the girl did in the front page picture discussed on the previous page. This would have been a better choice for the front page.

(Below) The errors in photographing the speedboat shot include shooting into the sun from the north side of the lake and using too short a lens. Using a boat to get closer to the action and shooting from the south side of the race might have produced a better shot.

■ WATER SPORTS

There are a variety of water sports that lend themselves to interesting feature shots. Boating, raft races, and hot weather water fights can produce winners. Newspapers love to publish pictures of the weather. If one publication won't buy a good shot, another often will.

This picture of a raft race was shot from a bridge. The guy with the big grin makes the picture. He is having great fun.

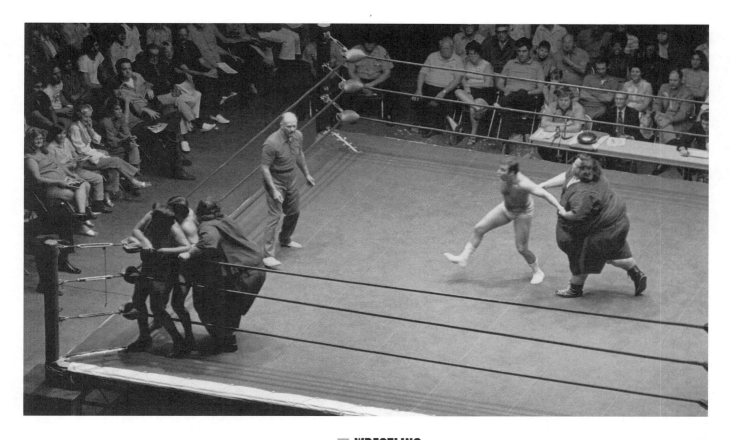

■ WRESTLING

Professional wrestling is a wonderful and entertaining freak show. The same photographic techniques are used to shoot both Professional wrestling and Greco-Roman wrestling.

Greco-Roman wrestling is a serious sport at many schools. The best shots are made from floor level because this perspective provides the best chance to see the athletes' faces. Fast lenses in the 50mm to 200mm range are recommended.

(above) This picture of a professional wrestling match in Detroit was shot from the balcony with a 135mm lens.

(right) Greco-Roman wrestling is very difficult to photograph because contestants rarely face the camera. Shooting from floor level with an 85mm lens improves the chances of capturing an interesting moment.

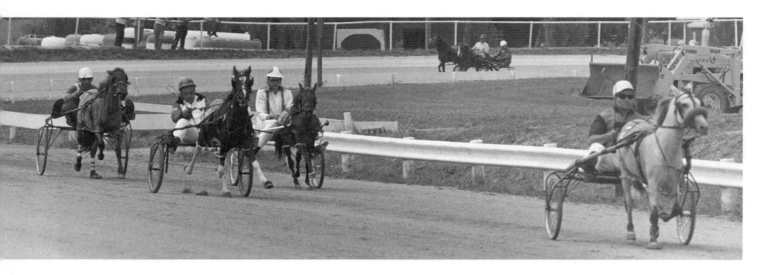

■ HORSES

All forms of horse racing need big telephoto lenses. Keep on the sunny side of the track to get the most detail from dark brown and black horses, and shoot from ahead of the action to show faces.

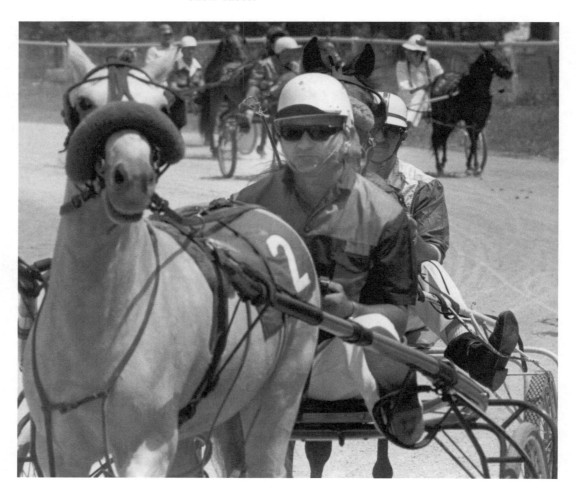

SPECIAL EFFECTS

Multiple exposures are effective for some pictures such as this shot promoting a 5K run. Dark backgrounds and side lighting are essential for success. For this shot an assistant triggered the flash three times while the photographer operated the camera.

"As your skills improve job opportunities will improve."

THE SPORTS PHOTOGRAPHY BUSINESS

COMPETITION

Competition for photography assignments is fierce at regional publications, and incredible at national magazines. While you are getting started, accept what work you can find. As your skills improve, job opportunities will improve. Few sports photographers start their businesses by selling pictures to the national sports publications. Beginners start shooting the local sports and giving away the pictures to parents, then selling to local people and publications.

Networking with other photographers is an important way to learn about opportunities. Join and attend national and local photography and journalism associations.

MAKING MONEY

Photographers wanting to be paid for their pictures need to be proficient in something even more important than photographic talent: salesmanship.

Salesmanship is the art of persuading a potential client that your product is her best choice to fulfill her particular needs. Factors clients may consider include price, timeliness, aggressiveness or self-confidence, experience, education, equipment, personal grooming, speaking skill, and portfolio.

A SPORTS PHOTOGRAPHY FABLE

Sports photography is a highly competitive cutthroat business. A story told by photojournalists in Dallas illustrates the seriousness of the competition. Sally and Peter, photographers from competing newspapers, were standing on the sideline at an important Dallas Cowboys game. "Dang. I'm almost out of film. Sally, will you loan me a roll of film? I still don't have the shot I was assigned," Peter said. "How many shots do you have left?" Sally asked. "One," Peter replied. Sally reached over to Peter's camera, fired off the last shot, and walked away laughing. Peter was never assigned to another Cowboys game. He was relegated to the less important and poorly paid college football games.

The moral of the story is that photographic enterprise is competetive, and failure or success may be dependent on factors other than talent, knowledge and equipment. Strive to be in the right place at the right time, prepared with everything you need.

Talent is not enough to guarantee success. The best equipped, most knowledgeable and talented sports photographer in America will not earn a penny if she sits home next to the telephone and waits for the offers to roll in. Sports photographers need the support of a strong sales and marketing program for financial success to be possible.

FINDING THE MARKETS

Finding potential buyers for sports pictures is as simple as using a telephone directory or making a trip a library. Local phone books list local magazines, newspapers, and organization in the white and yellow pages. Most libraries have copies of *Writer's Digest*, *Photographer's Market*, *Writer's Market*, *Ayers Directory of Publications*, *Editor and Publisher Yearbook*, and the *Directory of Associations*. These directories list names, addresses and phone numbers of people that might want to buy pictures.

MARKETS

Every town in America has people and businesses wanting to buy sports pictures. Some of the potential buyers include:

- Advertisers
- Book publishers

- Broadcasters
- College public and alumni relations offices
- Company newsletters
- Internet web site operators
- Magazines
- Newspapers
- News services
- Parents of athletes
- Poster and greeting card publishers
- Service club newsletters
- School yearbooks
- Stock picture agencies

MAKING CONTACTS

Phone the local contacts and make appointments to show your portfolio. Ask to see the person who has purchasing authority. Don't rely on a friend or secretary to make contact on your behalf. One of the tenets of salesmanship is that the core of the product being sold is the salesman. Salesmen must establish a relationship of trust with the client. If the salesman is not self-assured and professional, the buyer will not trust the product being sold.

WORKING WITH CLIENTS

There is a pattern to sales presentations that may be likened to a mating dance performed between a pair of birds. Salesmanship in the United States follows a very formal ritual. Perform the ritual well and win the prize. Fail to follow the prescribed steps and you may lose.

■ THE SALES STEPS

- Dress to fit the part
- Greet the client
- Gain the client's trust
- Qualify the client
- Discover the client's needs
- Demonstrate your talent
- Trial close
- Overcome objections
- Close the deal

Each of these steps is covered in the sections below.

■ APPEARANCE

Clients make photo assignments based on many factors including appearance. When attempting to make sales, devia-

"Fail to follow the prescribed steps and you may lose."

tion from a mainstream appearance may limit the kind, quantity, and value of photo assignments a photographer wins.

Robert T. Malloy once wrote a bestseller titled *Dress for Success*. In the book he revealed the results of his research on how clothing influences first impressions. Malloy reports that the most influential color, cut and style of men's clothing is not consistent from city to city across America. When the book was first published in the 1970s, a blue pinstripe suit and vest with a red tie conveyed the most prestige and power in many regions. Mallory noted that in Dallas, Texas, no men's clothing store sells suits with vests. Men don't buy them there. Just 30 miles west, in Fort Worth, vests are available.

The lesson is: to fit in well, study the business clothing worn by the successful people in your town and copy it to fit in. But be careful not to dress far above the financial level of your clients. Please note a photographer's business attire differs from clothing worn on a shoot.

GREETING THE CLIENT

The first step is to greet the potential client. Experts agree that first impressions are very important when making sales calls. The first impression is reputed to take place in the first 10 seconds of a meeting. A poor first impression can spoil the ritual and loose the sale.

Always smile when meeting a client and shake her hand. Be pleasant, act assured and confident even if you are quaking in your shoes. Look your client in the eyes. Some clients won't trust someone that can not make eye contact.

GAIN CLIENT'S TRUST

In the second stage of the sales presentation, discussion centers on topics other than sports photography. Chit-chat and small talk allows the salesman and the client to size each other up before the presentation. Look for clues to the clients' hot buttons. Use positive hot buttons in your presentation to her. Negative hot buttons must be avoided during the presentation.

QUALIFY THE CUSTOMER

A sales presentation should not be one sided. The client may not be appropriate for you, they may not pay well enough, or they may be slow making payments. Some publications will want to pay for a photographer's work with free copies of the publication. Only raw beginners should consider working with these organizations. Part of qualifying a customer is to discover who really makes the assignments in an organization. Don't waste time on people that can't give you assignments.

"...act assured and confident even if your are quaking in your shoes."

■ DISCOVER THE CLIENT'S NEEDS

A vital step in the sales presentation is to discover a client's true needs. Do this by asking leading questions. Leading questions give the client opportunities to express her feelings about different styles of sports photography and different photographers. She will talk about photographers that succeeded for her and ones that failed. Use this information. These are important clues for a sales approach tailored to her. Always agree with her statements even if she is wrong or you disagree. Be sympathetic.

■ DEMONSTRATE YOUR TALENT

Showing the portfolio is the fun part. In this step talk about how you can solve the problems she just listed for you. Use your pictures as evidence. Control which pictures she sees and when she sees them. Put each picture in her hands one at a time. Edit your portfolio as you make your presentation. It is important to control this phase of the sales ritual.

■ TRIAL CLOSE

Sprinkle your presentations with questions that can only be answered with a yes. For example: isn't this a great solution for photographing a hockey team in a new way? Don't you agree that this picture of a motorcycle conveys the feeling of high speed? Don't you agree this picture of a diver with fingers just entering the water is unique?

Questions that are phrased to get a positive response are known as trial closes. By obtaining a series of "yes" answers, you ease the way for the big "yes." The "yes" to the question, "May I have the assignment to photograph the next game?"

■ OVERCOME OBJECTIONS

Clients may ask questions or pose objections during the trial closes. Don't be alarmed. Use the objections to your advantage. Agree with her concern. Show how the objection is not valid or how you will overcome the problem. Objections are not usually personal attacks. Always give a positively phrased answers.

■ CLOSE THE DEAL

When all her objections have been answered, ask for the assignment and then keep your mouth shut. In sales presentations, the next person to talk loses. Let the silence last minutes if needed. Look her in the eyes. Be patient and win.

■ PRACTICE

Sports photography take lots of practice. So do sales presentations. Ask friends to roleplay. They should play the clients and bring up every objection they can so you gain

> "In sales presentations, the next person to talk looses."

experience overcoming the issues. It is also important to be at ease handling the portfolio and finding the appropriate next picture to hand to the client.

▉ PRICING

Correct pricing of products and services is the difference between profit and loss as a sports photographer.

The fee structure tells picture buyers a great deal about a photographer. Under pricing will scare away more clients than over pricing does. A photographer that charges less than the prevailing rate is shouting very loudly that he is a beginner trying to break into the field. Beginners often produce poor work. They may not shoot enough film to provide a variety of images. Alternately, a novice could shoot far too many rolls of film and incur too many expenses.

Assignment editors hesitate to work with beginners or photographers they don't know. The reason is that an editor's job may be at risk with every assignment she makes. If she tries to save a few dollars by hiring unknown or inexpensive photographers, she risks receiving a series of bad pictures, or, even worse, no usable pictures at all! This could hurt her career and the publication.

Conversely, over charging is damaging if the photographer does not deliver the quality level implied by the pricing. Only photographers that are well-known in a particular market can charge more than their competition and expect to get assignments. They become well-known by regularly creating images that are superior to other photographers working in the same field.

Fortunately help is available. Two books, *The Photographer's Market* and *The Writer's Market*, published every year by Writers Digest Books, lists prices paid for pictures by thousands of publishers. They also print photography pricing guidelines. The guides are divided into markets such as advertising, large magazines, small magazines, postcards, greeting cards, calendars and on-line services.

Additional sources for pricing information include professional photography associations such as the National Press Photography Association and the American Society of Media Photographers. A list of photography associations is included in the appendix of this book.

Photographers may be asked to submit prices in either of two ways: day rates or bids.

With day rates, photographers are paid an agreed amount for every day spent on the assignment plus the actual expenses incurred during the shoot. *National Geographic* magazine and *Life* magazine use this method. These publications are famous for allowing photographers to spend weeks shooting for one

"...newspapers and magazines will pay more than $20,000..."

article. Day rates are fading from popularity as magazines lose advertising revenues to broadcasters.

A growing trend is for picture editors to request bids from photographers. Competitive bidding assures the publisher of low costs. Some bids are formalities for the selected photographer. Other times, when the relative skills of the photographers placing the bids are unimportant, a business will simply pick the lowest price.

Freelance photographers may choose to create a picture and story package, then try to sell it to a publication. This style of work provides sports photographers with the ultimate in personal freedom and creativity. The freedom is tempered with the knowledge that sales are unpredictable and payment is erratic. Some companies pay when the material is accepted for publication. Other publishers pay after the work has been printed. Many magazines schedule feature stories and pictures more than a year in advance. Waiting a year or more to be paid is bad business. Financially, the best practice is to submit freelance work only to publishers that pay on acceptance.

Current prices for pictures range from nothing to tens of thousands of dollars. *The Writer's Digest*, an annual guide for writers and photographers, lists many publications that expect the writers submitting stories to provide the pictures for free. On the other end of the scale, some national newspapers and magazines will pay more than $20,000 for one-time rights for a picture no one else has. A picture of a famous athlete laying dead next to his wrecked Porsche is more valuable to a national sports magazine than it is to the community's weekly newspaper.

Some factors that influence the value of a photograph include:

- Artistic quality of the image
- Difficulty of obtaining the image
- Image content
- Market demand for a particular image
- Negotiation skills
- News value
- Planned use of the image
- Prevailing prices for similar images
- Rarity
- Reputation of the photographer
- Subject
- Technical quality of the image
- Timeliness

With so many variables a photographer may be tempted to take the first offer. Don't commit until you have analyzed the value of the picture to the purchaser.

PICTURE RIGHTS

Sports photographers have two products to sell; their time, and the images they produce.

Some photo buyers contract for pictures under the "Work For Hire" rules of the Copyright Act of 1976. This is essentially selling work time. Under work for hire contracts and agreements, a photographer is paid for the work. All copyrights to the images belong to the organization that hired the photographer. The purchaser keeps all film shot. A contract or a written agreement is required to grant the purchaser all rights under work for hire. The contract should specify who provides film and processing and pays for other expenses a photographer could incur while on assignment.

In the absence of a work for hire agreement, the law provides that the photographer retains all the rights. Owning the copyright on a picture may or may not result in more earnings from a particular image.

Photographers can sell or rent their copyrights to others under many different terms and conditions. Some of the common terms include:

ALL RIGHTS

Exclusive use of an image in any media is assigned to the purchaser for a specific length of time. After the time limit expires the purchaser may not use the image.

ONE-TIME RIGHTS

The purchaser may use the image only once, usually in only one media.

FIRST RIGHTS

The photographer guarantees the purchaser that the picture has not been published elsewhere in a specified geographic area.

SERIAL RIGHTS

The buyer is granted rights to use the image in a publication that is produced on a repeating schedule. Examples include magazines, newspapers and annuals.

EXCLUSIVE RIGHTS

The photographer grants a publisher exclusive rights to an image for use in a particular category of publication. Postcards are considered a different category from calendars. Granting exclusive rights to a postcard printer still allows the same picture to be sold to a calendar maker without violating the sales agreement with either company.

"...a portfolio ... is
the photographer's primary
sales tool."

■ ELECTRONIC RIGHTS

Electronic rights allow the use of images in computer software, CD-ROMs, on the Internet and World Wide Web.

■ PROMOTION RIGHTS

Permission is granted to use the picture to advertise the publication in which the picture was used.

■ RIGHTS IN COMBINATION

Hundreds of different combinations of rights are possible with many complex limitations and qualifying terms.

In the United States, the creator of a work is presumed to own the copyright. However it is easier to prove any legal dispute if three additional steps are taken:

1. Place a copyright notice on the border of each print and slide mount. The notice must have the © followed by the name of the creator and then the year of the copyright. For example: © David Neil Arndt 1999.

2. In some nations adding the phrase, "All rights reserved," provides additional protections. For example: © David Neil Arndt 1999. All rights reserved.

3. To recover damages from people or organizations that violate the copyright, it is very important that the work be registered with the U.S. Copyright Office before the offense occurred. For details on how to register the creation contact: Register of Copyrights, Library of Congress, Washington DC 20559. or telephone (202) 707-9100 and request form VA (visual arts).

A single one time fee can register many pictures. The fee changes from year to year.

Some nations do not recognize the legal concept of copyright protection. Yet others have copyright laws which they do not enforce. This is a major issue for photographers seeking overseas sales. Seek legal advice on protecting copyrights in other countries.

PORTFOLIOS

Much is written about portfolios. The purpose of a portfolio is to display the best work a photographer can do. Great care must be devoted to creating a portfolio as it is the photographer's primary sales tool.

A consensus appears to be that mounted and matted prints are superior to slides when making a presentation in person. 8x10 inch prints on 11x14 boards are acceptable, as are 11x14s on 16x20 inch mattes.

An alternative to carrying a heavy box of mounted pictures is to display them in a binder. These are available in several styles at art supply stores. Some can hold 16x20 inch pictures.

Portfolios that must be submitted for review, without the photographer present, may be in either slide or print form. The choice belongs to the client.

Slide portfolios should use duplicates. Multiple sets of slides permit several portfolio reviews to be conducted simultaneously. Duplicates reduce the financial and emotional impact if the portfolio is lost or damaged. Slides are less expensive to mail and are easier to pack and ship than prints.

A growing trend is to create a special CD-ROM which contains several specialty portfolios. This method of distributing portfolios is becoming common practice in the stock photography industry. The CD-ROMs must be compatible with Windows 95 and Macintosh platform computers. This usually means the pictures are recorded onto the CD in both formats.

WEB PAGES

The World Wide Web is a very popular way of displaying a portfolio.

Pictures display with the image quality of a newspaper photograph. It is good enough to display a portfolio to a potential client and motivate her to do a telephone interview or ask for a meeting.

Web surfers are impatient. They will not wait very long for pictures to display. They get upset and give up on the page if a picture fails to appear properly. Often the problem is the fault of the web page. Pictures must be small in order to display quickly. Most computer monitors can only display pictures at about 72 lines per inch. Higher resolution images don't look any different than lower resolution images, they merely waste time. Keep file sizes below 25 kilobytes. JPEG (called JPG in Windows 95) format pictures can be made smaller than GIF format pictures at the same image resolution.

Files of both formats can be opened and viewed automatically by common web browsers and computer platforms.

Dividing a portfolio into topics is another method of speeding access. From the first web page, provide links to separate pages for each topic. This avoids the wait for a dozen pictures to appear on the first page. It also allows a client to choose the topic she is interested in viewing. The KISS principle (Keep It Simple Stupid) applies to portfolio web pages.

"A portfolio must be tailored to fit the needs of each client."

Animation, sound and other interactive gimmicks show HTML (Hyper Text Markup Language) programming skills, but distract potential clients from the images, and it also slows access.

Search engines such as Yahoo! and Excite find web sites by looking for Metatags. Metatags are HTML code markers used in web page programming. Metatags are not visible to web surfers. Metatags describe the contents of a page. Put as many Metatags into a web page as are appropriate to describe its contents. A sports photography web page might include Metatags for each sport and team pictured, the photographer's name and city, and as many different references to sports or action photography as can be imagined. Consider including some common misspellings.

CONSULTANTS

Some photographers hire consultants to help select the images for a portfolio. Consultants are not emotionally attached to particular pictures, nor are they interested in how difficult an image was to create. This detachment lets consultants make better picture choices. A good consultant must be very knowledgeable about sports. Friends may be poor at selecting a portfolio if they fear offending the photographer.

CUSTOMIZE EACH PORTFOLIO

A portfolio must be tailored to fit the needs of each client. If the client is looking for a sports generalist, include a variety of sports and several feature pictures in the selection. If an editor wants to hire someone to shoot high school soccer action pictures, show only high school soccer action.

Displaying a variety of techniques within a specialty can be helpful. For instance, show examples of color, black & white, flash photographs and pictures made through push processing. This shows a range of technical skills.

Opinions on the number of pictures to include in a portfolio vary. Recommendations range from ten to two dozen pictures. Most experts agree that it is better to have a ten-picture portfolio than to include inferior pictures for the sake of quantity.

PHOTOGRAPHER'S REPRESENTATIVES

One method for boosting income is to hire a photographer's representative. Representatives are sales professionals whose job is to find new assignments for their photographers. However, be warned, these agents are not interested in working with beginners or amateurs. They can not afford to waste their time on people that have not shown their ability to complete assignments in a timely, professional manner.

Photographers will be asked to prove his experience and skill before an agent will consent to represent them. Providing a portfolio, resume, and published samples (or tear-sheets) will accomplish this goal as these items are proof of a photographer's skills, expertise and experience. Tear sheets are so named because the pages are essentially torn from the publications.

Photographer's representatives are useful for winning assignments from clients outside of a photographer's home region. This can be important since most national publications are based in New York, Chicago and Los Angeles.

Agents may represent several photographers and artists. Usually each photographer will have a different specialty.

Agents also specialize; some will represent photojournalists. *Photographer's Market* and other references report these specialties. Contact only representatives that report they represent editorial, photojournalism or magazine photographers. The listings also report the preferred method of contacting these busy people. Following the published advice avoids offending an agent.

CONTRACTS

Detailed contracts are necessary to define the relationship between photographer and representative. A contract will specify commissions and fees, who collects payments from clients and how often they are distributed. Contract terms for representatives vary widely. The following are common practices:

- 20 - 30% commission on sales.
- New photographers may be asked to pay a monthly advance against commissions. When the agent's monthly commission from sales matches or exceeds the advance, the advance is dropped.
- Photographers pay between 0 and 100% of advertising expenses. They may also be required to pay for, produce and provide promotional pieces and direct mail material.
- Exclusive right to represent a photographer in specific subjects or geographic areas.

FINDING PHOTOGRAPHER'S REPRESENTATIVES

For a list of photography agents read *The Photographer's Market* or contact the Society of Photographer and Artist Representatives, 60 E. 42nd Street, Suite 1166, New York NY 10165; phone: (212) 779-7467. The society also provides educational programs and enforces a code of ethics.

"...consider electronic transmission of the best pictures."

PICTURE DELIVERY

Sports photographers may not always have the luxury of processing and editing their own film. On assignments with a tight deadline a photographer may be asked to deliver unprocessed film so the client's processing laboratory can rush the work and the editor can make quick decisions. Occasionally a client may insist that a courier service be used to deliver the film overnight.

If a courier service is too slow, consider electronic transmission of the best pictures. In electronic transmission, an image is digitized using a print or slide scanner attached to a computer. The resulting file is sent to the client via telephone lines. This can be done with e-mail or FTP.

■ E-MAIL

E-mail is a fine way to communicate with clients, but a horrible way of sending pictures. E-mail works only for very small files. Most internet providers have difficulty moving large files through e-mail software. Some have a one megabyte (1,024 Kilobytes) file limit. One megabyte may be adequate for small B&W images but it is far too small for quality reproduction of color pictures. Some e-mail software will interpret the lengthy transmission time needed for a large picture as an error. The e-mail program may stop the transmission in the middle of the picture. If an error happens the software may also prevent the recipient from accessing additional e-mail until the recipient contacts the internet provider and has the picture deleted from the e-mail server. Even if the file arrives correctly the recipient may not have the software or the knowledge to open and save the picture.

■ FTP

A superior picture transmission method is FTP (File Transmission Protocol). FTP transmission can send any size or format file. The sender uses a computer and modem to dial directly to the recipient's computer. The internet is bypassed. Contact the recipient for phone number, access codes, connections protocols, file types and sizes. Without this information the sending and receiving computers can't communicate and the pictures can't be delivered.

Analog modems with speeds ranging from 2400 kbps up to 33.6 kbps can be used in FTP work. Faster speeds are possible but they rely on protocols such as V.90, X.2 and K-Flex which are incompatible with each other. Some people use the digital ISDN type of modem. To assure success at speeds above 33.6 kbps, both the sending and receiving computer must use the same modem protocol.

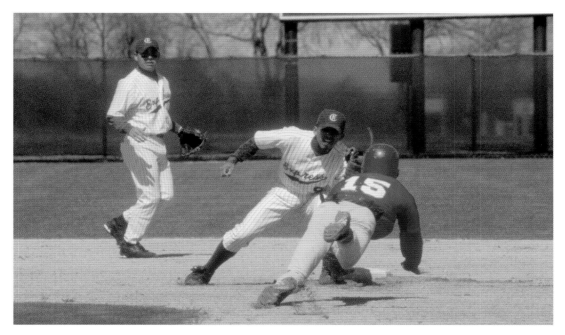

(left) An attempted steal of second base is brought close to the viewer by a 300mm lens.

(below) Many photographers are injured at rodeo events. Promoters continue to allow photographers in close because they value promotional shots. These rodeo photographers continue to risk their lives shooting because of the high prices good shots command.

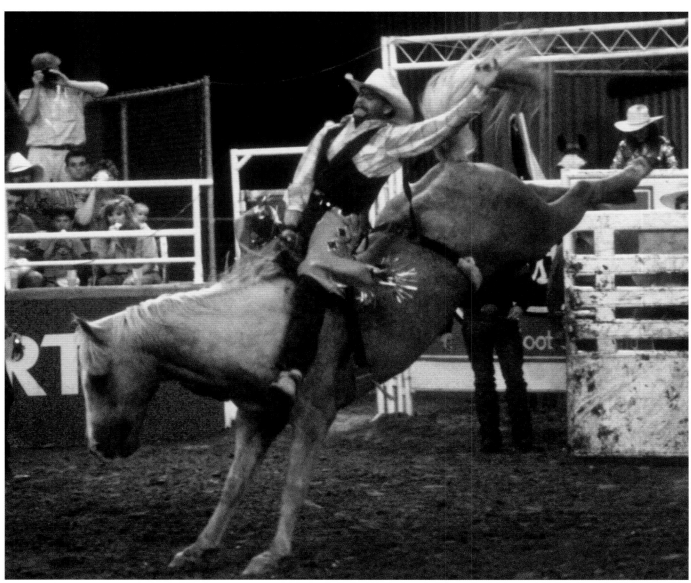

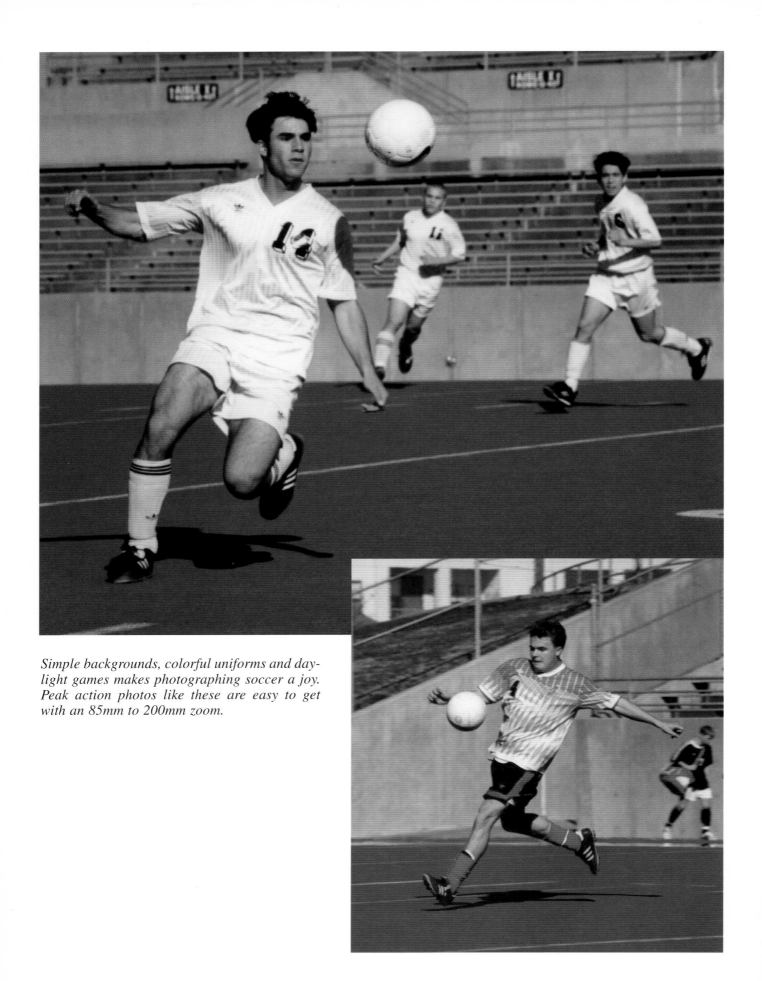

Simple backgrounds, colorful uniforms and day-light games makes photographing soccer a joy. Peak action photos like these are easy to get with an 85mm to 200mm zoom.

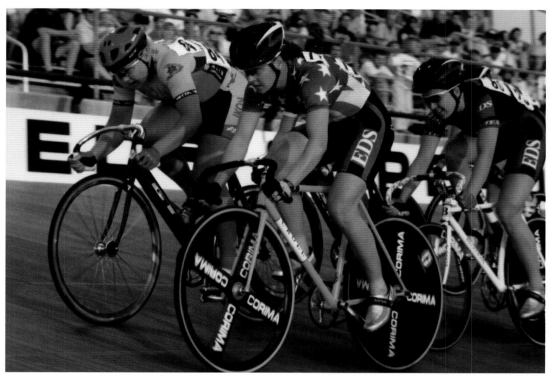

(left) Garish uniforms distinguish bicycle racing. Since the races are always close, a variety of expressions can be recorded on film.

(below) A football coach's hand gestures and expression tell the reader all they need to know about this scene.

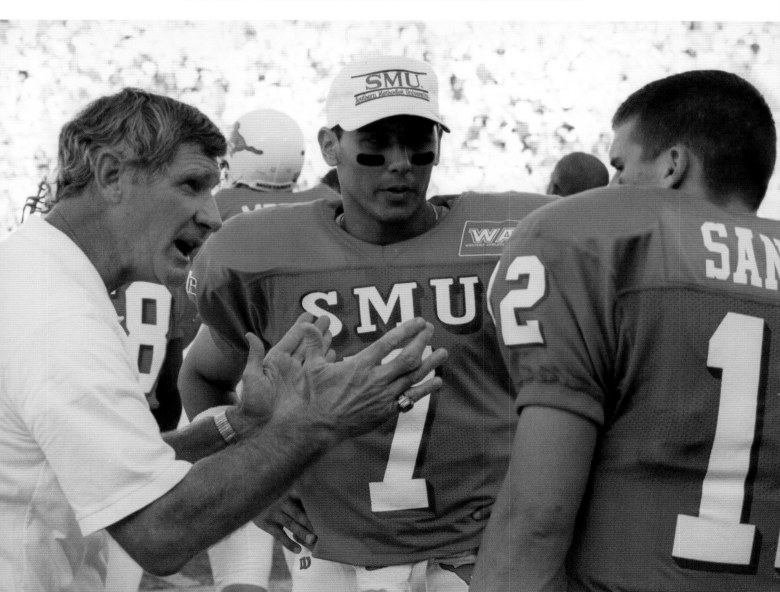

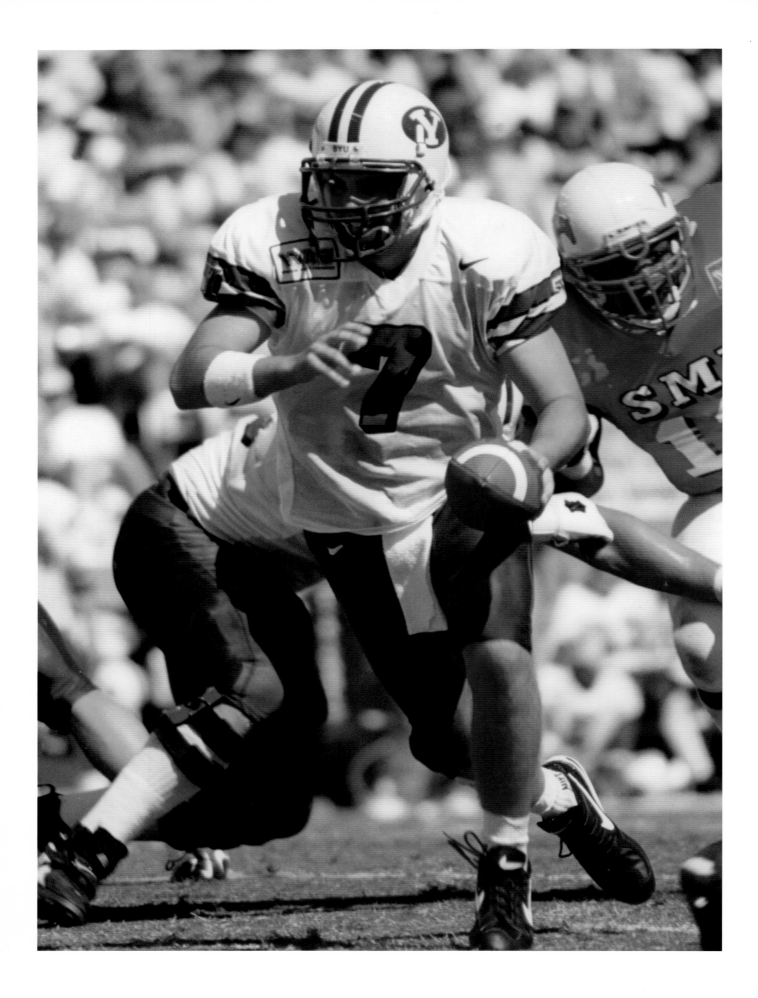

This picture of a Brigham Young University quarterback is typical of football pictures published in national magazines. With tighter cropping this shot can be resold as long as this fellow plays for BYU.

TAXES

One of the costs of living in the United States of America is heavy taxation. Most states collect corporate and income taxes in addition to sales taxes. Many cities collect income taxes. It is conceivable that the total income tax bite may approach half a photographer's income. The tax situation is complex and constantly changing. Accountants and Certified Public Accountants (CPAs) can provide essential services for the busy photographer. You might want to consider using their services.

The situation in Michigan provides a good example. A sports photographer that lives in Kalamazoo, and sells a picture to a Detroit magazine must pay Detroit city income tax on the sale because the Detroit ordinance taxes all income made in the city regardless of where a person lives. The same photographer that sells a picture to someone in Texas must collect and remit to the state of Texas the 8% Texas state sales tax. Some Texas cities charge an additional 1.25% municipal sales tax.

A hot issue in California in 1997 and 1998 was a sales tax leveled on art (including photos). Legislation in California taxes art sales based on the price of the picture or the value of the media it was delivered on. News reports indicate massive confusion about which tax rate to use even among the people collecting these taxes.

The solution is to retain the services of a good Certified Public Accountant. CPAs provide services beyond routine bookkeeping. CPAs know the tax laws and can reduce the photographer's tax burden. Every dollar that is not paid in taxes goes directly into the photographers pocket, or it can be reinvested into the business.

BUSINESS RECORDS

The key for successful tax savings is keeping accurate and complete financial records. Much of the day-to-day expenses of running a business are tax deductible. Most businesses store the actual paperwork, and use accounting software to track costs and financial status. Software packages are available for various accounting purposes.

COMPUTERS

Suitable business programs are available for Macintosh and PC based computers. Compatibility with the accountant's software is very important, as files created by one accounting application may not be compatible with another.

For example, QuickBooks is an accounting program that is very popular with small business owners. QuickBooks is available for Macintosh, Windows 95, Windows 3.1 and DOS

"The critical application for the sports photographer is Photoshop."

based computers. With the help of a free conversion program from Intuit, the maker of QuickBooks, Macintosh files can be translated to QuickBooks 5.0 for Windows 95. However, these converted files cannot be transferred back to the Macintosh.

Follow your accountant's recommendations when choosing business and accounting software. Because computers which run Windows 95, Windows 3.1 and DOS operating systems are the most common platforms, sports photographers may be faced with an expensive dilemma. Up to 70% of North America's publishers use Macintosh computers in their graphic arts production. Macintosh computers were the first to run serious publishing software such as Photoshop, Illustrator, Pagemaker, and QuarkXPress. A sports photographer's computer must be compatible with his client's and his accountant's. Two solutions are possible: buy a PC and a Macintosh computer, or buy a Macintosh and add an internal circuit board that runs the PC software needed by the accountant. Some software programs will run Windows 95 programs on a Macintosh without an extra circuit board.

A computer needs to be powerful enough to run the most demanding applications you will use. The critical application for the sports photographer is Photoshop. This program allows manipulation of pictures. Adobe, the maker of Photoshop, recommends that you have 3 to 5 times more Random Access Memory (RAM) than the largest images likely to be processed with the program. This is high-power computing. Most image editing professionals consider a computer with 100MB (megabytes) of RAM to be underpowered. The Macintosh line of computers is the platform of choice for picture editing. Some Macs can support over a gigabyte of RAM.

Other picture editing software is gaining acceptance in the graphic arts community. Applications like LivePicture, Kai's PhotoSoap and others are commonly used by picture editing professionals for their unique capabilities, filters and effects. Their file formats are compatible with Photoshop.

FREE SPEECH AND THE LIBEL LAWS

The First Amendment of the United States' Constitution guarantees freedom of speech and of the press. Free speech and a free press are the tools Americans use to protect all other freedoms and to keep government from being oppressive. American media has the freedom to publish almost anything it wishes.

The only limit to the power of free speech is libel. Libel happens when someone deliberately prints a damaging lie about a living person. American law protects people and companies from lies that are published with the intent to cause harm. Congress and the U.S. courts, which created the free press, wisely decided that libel law was an effective way of

keeping the media honest and focused on truth. These libel laws apply to photographers and photography as well.

It is possible for a photograph to libel someone. One way would be to use picture editing software to replace the face of a person, photographed while performing a criminal act, with the face of another person. One of the elements that must be proved to win a libel case is that the defendant deliberately lied with the intent to injure the victim.

A common belief is that "photographs do not lie." This is a demonstrably false belief. Even before the invention of photo editing software, skilled darkroom technicians have been able to add or remove people and objects from pictures. Another lie in photography is the lie of omission. Choosing to publish a picture of a friendly athlete instead of a picture of the game winning play made by an unfriendly player is a lie.

INVASION OF PRIVACY

A more important legal worry for photographers is invasion of privacy lawsuits. Invasion of privacy claims occur when a person objects to having his picture made or published. Again, the First Amendment and many court cases protect photographers from invasion of privacy claims.

Legal theory lists the following causes for invasions of privacy suits:

1. Intrusion on the plaintiff's seclusion or solitude.
2. Public disclosure of embarrassing private facts about the plaintiff.
3. Publicity which places the plaintiff in a false light in the public eye.
4. Appropriation, for the defendant's advantage, of plaintiff's name or likeness.

As a general rule, permission is not needed to make and publish pictures taken at public places if the pictures are used for journalistic or non-commercial purposes. Non-commercial purposes are generally considered any use except direct advertisement of a product or service. All the pictures in this book are considered non-commercial use. Thus the publisher and the writer of this book did not need permission to publish the pictures.

A public place is any place outside of a home, hotel room, or hospital. Public places include stadiums, arenas, portions of some buildings or schools, restaurants, or other places where a person cannot control who sees him. If a photographer standing in a street or on neighboring property can see inside a home, then the photographer can photograph the person inside that home without permission from the subject. The

"public figures
are subject to comment,
criticism, and being
photographed."

person has chosen not to control who sees her when she chose not to close the window blinds or curtains.

The law generally considers athletes public figures. A working definition of public figure is: anyone that a journalist wishes to write about, talk about or photograph for their print publication, radio or television broadcast or computer based communications. As a direct result of any activity they perform which brings them to the attention of journalists or photographers, public figures are subject to comment, criticism, and being photographed.

Because of the way the First Amendment is interpreted, public figures have fewer rights than ordinary Americans. Public figures have no control over how they are portrayed in the communications media. They usually cannot prevent publication of offensive or embarrassing pictures or articles. They rarely win lawsuits against publications that lie about them, damage their public image or invade their privacy. To win, an athlete must prove in court that the publication deliberately planned to lie and damage his reputation, career or relationships with other people.

A 1991 Texas Court of Appeals case illustrates the freedom photographers have when photographing amateur athletes. Larry McNamara was playing in a high school soccer game when he was photographed in action. The local newspaper, *The Brownsville Herald*, published the picture. After the paper was printed and distributed *The Brownsville Herald* and McNamara discovered the picture included a clear view of his genitals. He neglected to wear an athletic supporter. McNamara sued the paper and claimed invasion of privacy. He alleged the newspaper should have used a different photograph. McNamara lost. The court said the embarrassing photo was protected under Texas law and by the First Amendment of the U.S. Constitution.

Attorney Martha Churchill, who did most of the legal research for this section, wrote the following to further illustrate the rights of the sports photographer.

"Suppose you are at a high school football game, and you happen to get a picture of an important play, which shows a member of the public scratching himself in an embarrassing way. You have the right to take that picture, and show it or publish it anywhere you want so long as you are not trying to sell a product with it. You would be in a gray area if you wrote a caption under the picture saying 'Here is John Q. Public Jr., age 34, of 629 Main Street scratching himself while watching a touchdown at the high school game.' You

would be in really hot water, as a photographer, if you used the picture in an advertisement for Preparation H.

"Suppose you take a picture of a couple holding hands and kissing while watching the game, and it turns out the man told his wife he was 'working late at the office' while he was really out with his secretary watching the game and kissing. If the picture gets in the paper, that is his tough luck, and he had better explain it to his wife because he can't sue the newspaper for depicting him in a public place."

Photographer's rights are even better protected when shooting professional sports. In Chaves vs. Hollywood Camera, a professional boxer went to court to prevent a television crew from filming a fight. A Los Angeles court ruled in favor of Hollywood Camera. Chaves lost because he waived his right to privacy by participating in a public match. In professional sports the promoter of the event controls photography and broadcast rights. Chaves lost influence over how his image was used because he failed to negotiate to retain those rights when he signed the contract with the fight promoter.

It is common practice for athletes to retain the rights to their name and image when they are used for commercial purposes such as advertising endorsements. Some athletes make tens of millions of dollars every year from advertising. Use of pictures of people and athletes in books, newspapers, magazines, radio and television stories is not considered a "commercial purpose" by American courts. "Commercial purpose" is defined by courts as using a person's name or image to sell a product.

The O.J. Simpson case is an example of how little power athletes have over their public image. Simpson was a famous football player and later a sports broadcaster for ABC television. After he was accused of murdering his former wife and another man, photographers staked out his home 24 hours a day for more than a year. They followed him everywhere and photographed every activity. More than a year after a jury decided he did not commit the murders, photographers still followed him. They hoped to create an embarrassing picture. The more embarrassing the shot, the more valuable the picture. Photographers are so well protected by the First Amendment that Simpson did not ask a court to restrict the photographers' activities.

The most famous case where a public figure was successful in limiting a photographer's activities was decided in 1967 when Jackie Kennedy Onassis, the wife of assassinated presi-

"...you don't
need permission to take a
picture of a dead person."

dent John F. Kennedy, sued Ron Galella. Galella reportedly stalked Onassis for months. After the first trial the court ordered Galella to stay more than 100 yards from her home and 50 yards away from Onassis at all times. Galella was free to continue photographing Onassis, but only from beyond the specified distance. He started using super telephoto lenses to compensate. Galella appealed and the court modified the restrictions to permit Galella as close as 25 feet of the president's widow.

Galella lost the privilege to shoot from close-up because of his behavior. Court testimony indicates Galella used very unorthodox methods geared to produce unusual reactions from Onassis. Unusual reactions earn photographers more money than ordinary pictures. In one incident, John Kennedy Jr., son of the president, was bicycling in New York City's Central Park with his contingent of Secret Service agents when Galella jumped out of some bushes in an attempt to startle the boy and thereby create a unique picture. According to reports, Kennedy nearly crashed his bicycle. Galella's intrusive behavior triggered the court action and resulted in the court imposed restrictions. Other photographers who photographed Onassis from time to time experienced little trouble from the family.

Occasionally an athlete will become so irritated by a photographer that she or he will punch the offending snap-shooter or break a camera. Other reporters and photographers react to this violence by reporting the incident world wide. The public figure usually apologizes, replaces the camera equipment and settles any legal action out of court.

In a 1986 case, known as Fasching vs. Kallinger, a New Jersey court ruled that if a player is injured while playing hockey, photographers can shoot and publish the pictures. If the player is alive and hospitalized, photographers can not enter the player's room and make pictures without permission. If you run into his hospital room moments after he dies and take pictures of him, that's okay because you don't need permission to take a picture of a dead person. A dead person cannot sue for libel, defamation of character or invasion of privacy.

An exception is in the state of Michigan. Photographing a corpse is considered invasion of the surviving relative's privacy. The law came about after a film crew, diving on the wreck of the ore freighter Edmund Fitzgerald, photographed and broadcast images of an unidentifiable body on the wreck. Family members persuaded the Michigan legislature to ban publication of such pictures. The law had not been tested in court at the time this book was written.

MODEL RELEASES

The rules are different when an athlete cooperates with a photographer by posing for photos. All advertisers, and most magazines and broadcasters, insist the subject sign a model release. Few newspapers use model releases. Model releases are legal contracts giving the photographer permission to create and publish the picture. The subject may choose to limit the use of the picture. She may prohibit the image from being used in any advertising or on television. A model release may specify how the athlete is to be paid for posing in the photograph. From the photographer's viewpoint the model release provides some protection against the athlete changing her mind and suing for damages after publication.

Some publications use a model release form written by staff attorneys to specifically meet their needs. Photographers can purchase a pad of pre-printed model releases at many large camera shops. The content of model releases vary widely.

Stock photo agencies make money by selling picture publication rights to publishers and advertisers. Agencies demand model releases for everyone that can be identified in a picture. Since they cannot guess how a picture will be used they need the fullest range of publication rights.

Mastering the techniques of sports photography is a high goal that will take a lifetime to achieve, because new methods and styles of photography are constantly being invented. A higher level of achievement is always possible if you work at your craft and seek to improve your images.

APPENDICES

ASSOCIATIONS

SPORTS ASSOCIATIONS

Association for Women in Sports Media, P.O. Box 4205, Hililani, HI 96789. (305) 376-3496.

Baseball Writers Association of America, 78 Olive St. Lake Grove, NY 11755. (516) 981-7938.

Boating Writers International, P.O. Box 10, Greentown, PA. 18426 (717) 857-1557.

Bowling Writers Association of America, 6357 Siena St., Centerville, OH 45459 (513) 433-8363.

Editorial Freelancers Association, 71 W. 23rd St., Ste. 1504, New York, NY 10010 (212) 929-5400.

Freelance Editorial Association, P.O. Box 380835, Cambridge, MA 02238-0835 (617) 643-8626.

International Motor Press Association, 1756 Broadway, room 26J. New York, NY 10019. (212) 315-4900.

National Collegiate Baseball Writers Association, University of Florida, P.O. Box 14485, Gainesville, FL 32604-2485. (904) 357-4683.

National Motorsports Press Association, P.O. Box 500, Darlington, SC 29532. (803) 395-8821.

National Sportscasters and Sportswriters Association, P.O. Box 559 Salisbury, NC 28144. (704) 633-4275.

National Turf Writers Association, 1314 Bentwood Way, Louisville, KY 40223. (502) 245-3809.

National Women Bowling Writers Association, 5301 S. 76th St. Greendale, WI 53129. (414) 421-9000.

North American Ski Journalists Association, P.O. Box 5334, Takoma Park, MD 20913. (301) 864-6428.

Professional Basketball Writers Association, 30 Oakland Park Blvd., Pleasand Ridge, MI 48069-1109. (810) 542-0805.

Professional Hockey Writers Association, 1480 Pleasant Valley Way, # 44, West Orange, NJ 07052. (201) 669-8607.

United States Harness Writers Association, P.O. Box 10, Batavia, NY 14021. (716) 343-5900.

World Bowling Writers, 200 S. Michigan Ave., # 1430, Chicago, IL 60604. (312) 341-1110.

PHOTOGRAPHY ASSOCIATIONS

American Society of Photographers, P.O. Box 3191, Spartanburg, SC 29304. (803) 582-3115.

National Press Photographers Association, 3200 Croasdaile Dr. # 306, Durham, NC 27705. (800) 289-67721.

The American Society of Media Photographers, 14 Washington Rd., # 502, Princeton Junction, NJ 08550-1003. (609) 799-8300.

PHOTOJOURNALISM PROGRAMS

The National Press Photographers Association reports the following schools have photojournalism programs. Their web sites are listed for further information.

UNIVERSITIES

Abilene Christian University, http://www.acu.edu
Ball State University, http://www.bsu.edu
Indiana University, http://www.indiana.edu
Kansas State University, http://www.ksu.edu
Michigan State University, http://www.msu.edu
Ohio University, http://www.viscom.ohiou.edu
Rochester Institute of Technology, http://www.rit.edu
San Francisco State University, http://www.sfsu.edu
San Jose State University, http://www.sjsu.edu
Syracuse University, http://www.syracuse.edu
University of Florida, http://www.jou.ufl.edu
University of Georgia, http://www.uga.edu
University of La Verne
University of Missouri, http://www.missouri.edu
University of Nebraska, http://www.unl.edu
University of North Carolina, http://www.unc.edu
Western Kentucky University, http://www.wku.edu

COMMUNITY COLLEGES

Lansing Community College,
 http://www.lansing.cc.mi.us
Randolph College,
 http://www.randolph.cc.nc.us/Randolph

SUGGESTED READING

_____. *The ASMP Professional Business Practices In Photography.* American Society of Media Photographers. New York: Allworth Press, 1997.

_____. *How to Catch the Action.* The Kodak Library of Creative Photography, 1983.

_____. *Mastering Composition and Light.* The Kodak Library of Creative Photography, 1983.

_____. *Photographing the Drama of Daily Light.* The Kodak Library of Creative Photography, 1983.

_____. *Photographers Market.* Cincinnati, OH: Writers Digest Books.

_____. *United Press International Stylebook.* United Press International. Lincolnwood, Illinois: National Text Book Company, 1995.

Benson, Harry. *Harry Benson On Photojournalism.* New York: Harmony Books, 1982.

Benson, Harry. *People.* San Francisco: Chronicle Books, 1990.

Cappon, Rene J. *Associated Press Guide to News Writing.* New York: Prentice Hall, 1991.

Chapnick, Howard. *Truth Has No Ally: Inside Photojournalism.* Columbia, MI: University of Missouri Press, 1994.

Crawford, Tad. *Business and Legal Forms for Photographers.* New York: Allworth Press, 1997.

Edey, Maitland. *Great Photographic Essays From LIFE.* Boston: New York Graphic Society, 1978.

Faber, John. *Great News Photos and The Stories Behind Them.* Mineola, NY: Dover Publications, Inc., 1990.

Freeman, John. *How to Take Great Photographs: A Practical Photography Course.* New York: Smithmark Publishers, 1995.

Grill, Tom and Mark Scanlon. *Photographic Composition.* New York: Amphoto, 1983.

Hargrave, Sean. *Sports and Adventure Photography.* New York: Amphoto, 1995.

Heron, Michael and David McTavish. *Pricing Photography: The Complete Guide To Assignment & Stock Pricing.* New York: Allworth Press, 1997.

Hicks, Wilson. *Words and Pictures.* NewYork: Harper &Brothers, 1952.

Hilton, Jonathan. *Action Photography.* Switerzland: Rotovision SA, 1997.

Hollenbeck, Cliff. *Big Buck Selling Your Photography.* Buffalo, NY: Amherst Media, 1995.

Hopkinson, Amanda. *150 Years of Photo Journalism Volume I and Volume II.* Koln, Germany: Konemann, 1995.

Horton, Brian. *The Associated Press Photojournalism Stylebook.* New York: Addison-Welsey Publishing Company, 1990.

Hoy, Frank P. *Photojournalism - The Visual Approach.* Englewood Cliffs, New Jersey: Prentice Hall, 1986.

Jasperson, William. Magazine: *Behind the Scenes at Sports Illustrated.* New York: Little Brown & Company, 1983.

Kane, Art. *The Persuasive Image.* New York: Morgan and Morgan, 1975.

Kennerly, David Hume. *Shooter.* New York: Newsweek Books, 1979.

Kerr, Norman. *Lighting Techniques for Photographers.* Buffalo, NY: Amherst Media, 1998.

Kobre, Kenneth and Betsy Brill. *PHOTO-JOURNALISM: The Professionals' Approach.* Newton, MA: Butterworth-Heinemann, 1995.

LaBelle, Dave. *The Great Picture Hunt.* Bowling Green, Kentucky: Dave LaBelle, 1991.

Lacayo, Richard and George Russell. *Eyewitness, 150 years of Photojournalism.* New York: Time Inc/Oxmoor House, Inc., 1990.

Life. *The Best of Life.* New York: Time, Inc., 1973.

Mark, Mary Ellen and Annie Liebovitz. *Photojournalism; The Woman's Perspective.* Los Angles: Petersen Publishing Company, 1974.

McDougal, Angus and Veita Jo Hampton. *Picture Editing and Layout.* Viscom Press, 1990.

McQuilkin, Robert. *How to Photograph Sports & Action.* Tucson, AZ: H.P. Books, 1982.

Patterson, Freeman. *Photography and the Art of Seeing.* Toronto, Canada: Van Nostrand Reinhold, 1997.

Ritchin, Fred. *In Our Own Image.* New York: Aperture Foundation, Inc., 1990.

Rothstein, Arthur. *Photojournalism.* Garden City, NY: Amphoto, 1979.

Rubin, Len S. *Editor with a Camera: Picture Window on a Small Town.* New York: A.S. Barnes and Company, 1968.

Sahadi, Lou and Mickey Palmer. *The Complete Book of Sports Photography.* New York: Amphoto, 1982.

Shay, Arthur. *Sports Photography: How to take great action shots.* Chicago: Contemporary Books, 1981.

Sherer, Michael D., Ph.D. *No Pictures Please, It's The Law.* Durham, NC, 1994.

Shipman, Carl (editor). *How to Compose Better Photos.* Tucson, AZ: H.P. Books, 1981.

Smith, Bill. *Designing a Photograph.* New York: Amphoto, 1985.

Sontag, Susan. *On Photography.* New York: Farrar, Straus and Giroux, 1973.

Spina, Tony. *On Assignment: Projects in Photojournalism.* New York: Amphoto, 1982.

Weinberg, Adam D. *On The Line: The New Color Photojournalism.* Philadelphia, PA: University of Pennsylvania Press, 1986.

Willins, Michael. *The Photographer's Market Guide to Photo Submission and Portfolio Formats.* Cincinnati, OH: Writers Digest Books, 1997.

Yapp, Nick. *Camera In Conflict.* Koln, Germany: Konemann, 1996.

Zimmerman, John & Mark Kauffman. *Photographing Sports.* New York: Petersen Publishing Company, 1975.

Other Books from Amherst Media, Inc.

Basic 35mm Photo Guide
Craig Alesse

Great for beginning photographers! Designed to teach 35mm basics step-by-step. Features the latest cameras. Includes: 35mm automatic and semi-automatic cameras, camera handling, *f*-stops, shutter speeds, and more! $12.95 list, 9x8, 112p, 178 photos, order no. 1051.

Camera Maintenance & Repair Book 1
Thomas Tomosy

A step-by-step guide to mastering camera repair. Includes: testing camera functions, maintenance, tools for repair, repairs for accessories, camera electronics, plus "quick tips" for maintenance and more! $29.95 list, 8½x11, 176p, order no. 1158.

Don't Take My Picture
Craig Alesse

This is the second edition of the fun-to-read guide to taking fantastic photos of family and friends. Best selling author, Craig Alesse, shows you in clear, simple language how to shoot pictures, work with light, and capture the moment. Make everyone in your pictures look their best! $9.95 list, 6x9, 104p, 100+ photos, order no. 1099.

Camera Maintenance & Repair Book 2
Thomas Tomosy

Advanced troubleshooting and repair. Builds on the basics covered in the first book. Includes; mechanical and electronic SLRs, lenses, medium format, repairing plastic and metal parts, and more. $29.95 list, 8½x11, 176p, 150+ photos, charts, tables, appendices, index, glossary, order no. 1558.

Build Your Own Home Darkroom
Lista Duren & Will McDonald

This classic book shows how to build a high quality, inexpensive darkroom in your basement, spare room, or almost anywhere. Information on: darkroom design, woodworking, tools, and more! $17.95 list, 8½x11, 160p, order no. 1092.

Restoring Classic & Collectible Cameras (Pre 1945)
Thomas Tomosy

A must for camera buffs and collectors! Clear, step-by-step instruction for restoring your valuable collectible camera's leather, brass and wood parts. $34.95 list, 8½x11, 128p, b&w photos and illustrations, glossary, index, order no. 1613.

Into Your Darkroom Step-by-Step
Dennis P. Curtin

The ideal beginning darkroom guide. Easy to follow and fully illustrated each step of the way. Information on: equipment you'll need, set-up, making proof sheets and much more! $17.95 list, 8½x11, 90p, hundreds of photos, order no. 1093.

Restoring the Great Collectible Cameras (1945-70)
Tomas Tomosy

More step-by-step instruction on how to repair collectible cameras. Covers postwar models (1945-70). Hundreds of illustrations show disassembly and repair. $29.95 list, 8½x11, 128p, 200+ photos, index, order no. 1560.

The Beginner's Guide to Pinhole Photography
Jim Shull

Take pictures with a camera you make from stuff you have around the house. Develop the results at home! Pinhole photography is fun, inexpensive, educational and challenging. $17.95 list, 8½x11, 80p, 55 photos, charts & diagrams, order no. 1578.

Computer Photography Handbook
Rob Sheppard

Learn to make the most of your photographs using computer technology! From creating images with digital cameras, to scanning prints and negatives, to manipulating images, you'll learn all the basics of digital imaging. $29.95 list, 8½x11, 128p, 150+ photos, index, order no. 1560.

Big Bucks Selling Your Photography
Cliff Hollenbeck

A complete photo business package for all photographers. Includes secrets to making big bucks, starting up, getting paid the right price, and creating successful portfolios! Features setting financial, marketing and creative goals. This book will help to organize business planning, bookkeeping, and taxes. $15.95 list, 6x9, 336p, order no. 1177.

Great Travel Photography
Cliff and Nancy Hollenbeck

Learn how to capture great travel photos from the Travel Photographer of the Year! Includes helpful travel and safety tips, equipment checklists, and much more! Packed full of photo examples from all over the world! Part of the Amherst Media's Photo-Imaging Series. $15.95 list, 7x10, 112p, b&w and color photos, index, glossary, appendices, order no. 1494.

Telephoto Lens Photography
Rob Sheppard

A complete guide for telephoto lenses! This book shows you how to take great wildlife photos, portraits, sports and action shots, travel pics, and much more! Features over 100 photographic examples. $17.95 list, 8½x11, 112p, b&w and color photos, index, glossary, appendices, order no. 1606.

Wedding Photographer's Handbook
Robert and Sheila Hurth

The complete step-by-step guide to succeeding in the exciting and profitable world of wedding photography. Packed with shooting tips, equipment lists, must-get photo lists, business strategies, and much more! $24.95 list, 8½x11, 176p, index, b&w and color photos, diagrams, order no. 1485.

Lighting for People Photography
Stephen Crain

The complete guide to lighting. Includes: set-ups, equipment information, how to control strobe and natural lighting, and much more! Features diagrams, illustrations, and exercises for practicing the lighting techniques discussed in each chapter. $29.95 list, 8½x11, 112p, b&w and color photos, glossary, index, order no. 1296.

Infrared Photography Handbook
Laurie White

Covers all aspects of black and white infrared photography: focus, lenses, film loading, film speed rating, heat sensitivity, batch testing, paper stocks, filters, and more. Black & white photos illustrate how IR film reacts in portrait, landscape, and architectural photography. $29.95 list, 8½x11, 104p, 50 b&w photos, charts & diagrams, order no. 1419.

The Art of Infrared Photography / 4th Edition
Joe Paduano

A practical, comprehensive guide to the art of infrared photography. Tells what to expect and how to control results. Includes: anticipating effects, shooting color infrared, digital infrared, using filters, focusing, developing, printing, handcoloring, toning, and more! $29.95 list, 8½x11, 112p, order no. 1052.

Infrared Nude Photography
Joseph Paduano

A stunning collection of images with how-to text which discusses how to shoot the infrared nude. Over 50 infrared photos presented as a portfolio of classic nude work. Shot on location in natural settings, including the Grand Canyon, Bryce Canyon and the New Jersey Shore. $29.95 list, 8½x11, 96p, over 50 photos, order no. 1080.

Black & White Nude Photography
Stan Trampe

This book teaches the essentials for taking successful fine art nude images. Includes info on finding your first models, selecting equipment, shooting on location, scenarios of a typical shoot, and more! Includes 60 photos taken with b&w and infrared films. $24.95 list, 8½x11, 112p, index, order no. 1592.

Glamour Nude Photography
Robert and Sheila Hurth

Create stunning nude images! Robert and Sheila Hurth guide you through selecting a subject, choosing locations, lighting, and shooting techniques. Includes information on posing, equipment, makeup and hair styles, and much more! $24.95 list, 8½x11, 144p, over 100 b&w and color photos, index, order no. 1499.

Swimsuit Model Photography

Cliff Hollenbeck

A complete guide to swimsuit model photography. By the author of *Big Bucks Selling Your Photography* and *Great travel Photography*. $29.95 list, 8½x11, 112p, over 100 b&w and color photos, index, order no. 1605.

Black & White Model Photography

Bill Lemon

Create dramatic sensual images of models. Explore lighting, setting, equipment use, posing and composition with the author's discussion of 60 unique images. $29.95 list, 8½x11, 128p, 60 b&w photos and illustrations, index, order no. 1577.

Black & White Portrait Photography

Helen Boursier

Make money with B&W portrait photography. Learn from top B&W shooters! Studio and location techniques, with tips on preparing your subjects, selecting settings and wardrobe, lab techniques, and more! $29.95 list, 8½x11, 128p, 130+ photos, index, order no. 1626.

Profitable Portrait Photography

Roger Berg

Learn to profit in the portrait photography business! Improve studio methods, lighting techniques and posing to get the best shot in the least time. $29.95 list, 8½x11, 104p, 120+ B&W and color photos, index, order no. 1570.

Achieving the Ultimate Image

Ernst Wildi

Ernst Wildi shows any photographer how to take world class photos. Features: exposure, metering, the Zone System, composition, evaluating an image, and more! $29.95 list, 8½x11, 128p, 120 B&W and color photos, index, order no. 1628.

Lighting Techniques for Photographers

Norm Kerr

This book teaches how to predict the effects of light. It covers the interplay of light qualities, as well as color compensation and manipulation of light and shadow. $29.95 list, 8½x11, 120p, 150+ color and b&w photos, index, order no. 1564.

Handcoloring Photographs Step-by-Step

Sandra Laird & Carey Chambers

Learn to handcolor photographs step-by-step with the new standard handcoloring reference. Covers a variety of coloring media. Includes colorful photographic examples. $29.95 list, 8½x11, 112p, 100+ color and b&w photos, order no. 1543.

Special Effects Photography Handbook

Elinor Stecker Orel

Create magic on film with special effects! Step-by-step instructions guide you through each effect, using things you probably have around the house. $29.95 list, 8½x11, 112p, 80+ color and b&w photos, index, glossary, order no. 1614.